ZAPIRO

DA ZUMA
CODE

Cartoons from *Mail & Guardian, Sunday Times,*
and *Independent Newspapers*

DOUBLE
STOREY
a juta company

Acknowledgements: Thanks to my editors at the Mail & Guardian
(Ferial Haffajee), at the Sunday Times *(Mondli Makhanya,
Ray Hartley − thanks for book title), and at* Independent
Newspapers *(Tyrone August, David Canning, Alide Dasnois,
Chris Whitfield, Moegsien Williams); and the production staff
at all the papers; my assistant Carol Wilder; Bridget Impey,
Russell Martin and all at Double Storey; Nomalizo Ndlazi;
my children Tevya and Nina, and my wife Karina*

Published 2006 by
Double Storey Books, a division of Juta & Co. Ltd,
Mercury Crescent, Wetton, Cape Town, South Africa

in association with

© 2006 Jonathan Shapiro

ISBN 1-77013-101-9

Cover design by Jonathan Shapiro

Page layout by Claudine Willatt-Bate
Printing by ABC Press, Epping, Cape Town

For Karina
for your support while producing your own book

Other ZAPIRO books

The Madiba Years (1996)

The Hole Truth (1997)

End of Part One (1998)

Call Mr Delivery (1999)

The Devil Made Me Do It! (2000)

The ANC Went in 4x4 (2001)

Bushwhacked (2002)

Dr Do-Little and the African Potato (2003)

Long Walk to Free Time (2004)

Is There a Spin Doctor In the House? (2005)

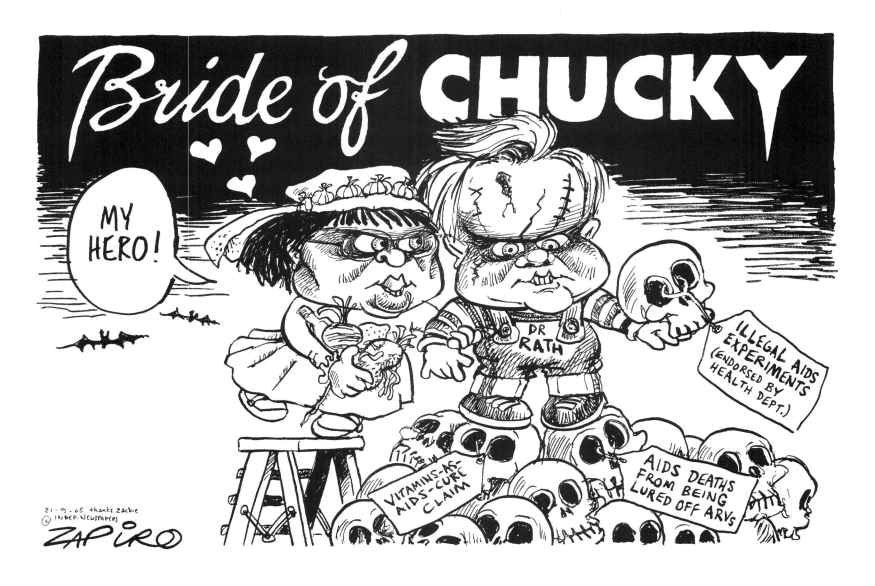

The Health Department finds no fault with Dr Matthias Rath's illegal
clinical trials on HIV-positive people, though some died after discarding
anti-retrovirals in favour of vitamins touted by Rath as an Aids cure

21 September 2005

5

THE TRUMAN SHOW

Reality TV — PG SVL

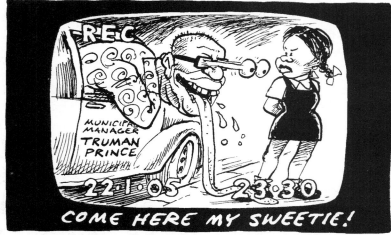

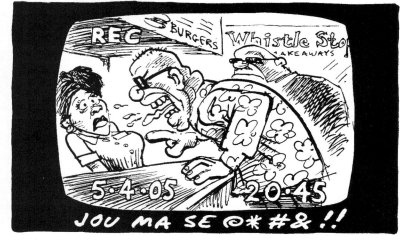

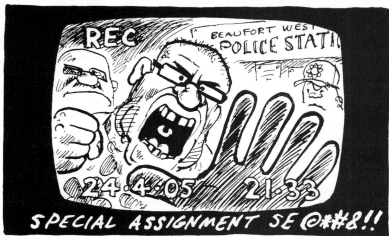

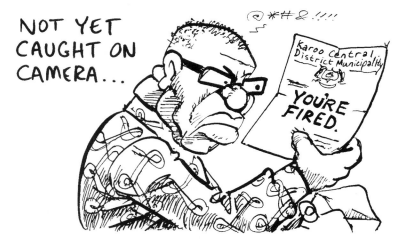

22 September 2005

Months after SABC footage exposing Truman Prince soliciting minors, abusing shop assistants and threatening journalists, the municipal district he manages won't discuss whether his job is on the line

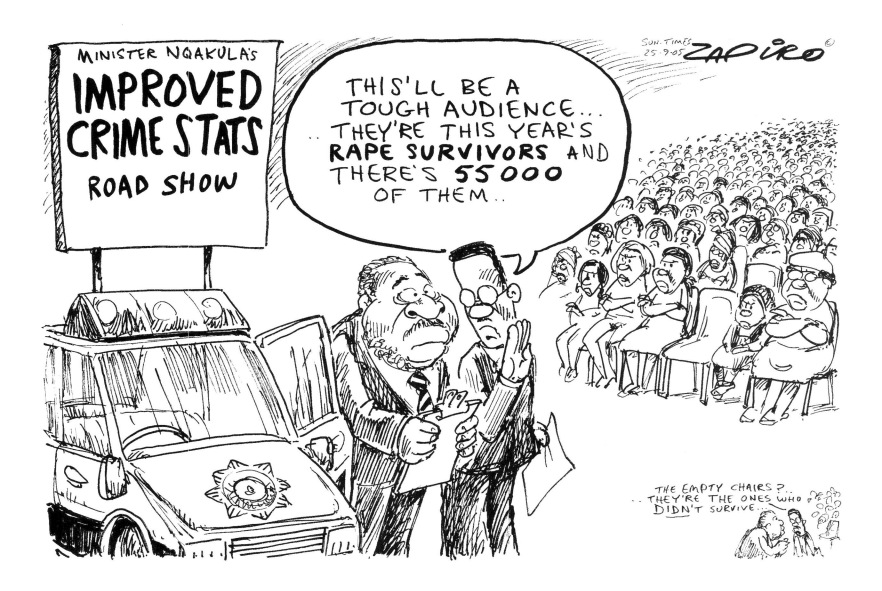

25 September 2005

Annual release of police crime statistics. Safety and Security Minister Charles Nqakula paints a rosy picture but the rape level has worsened.

7

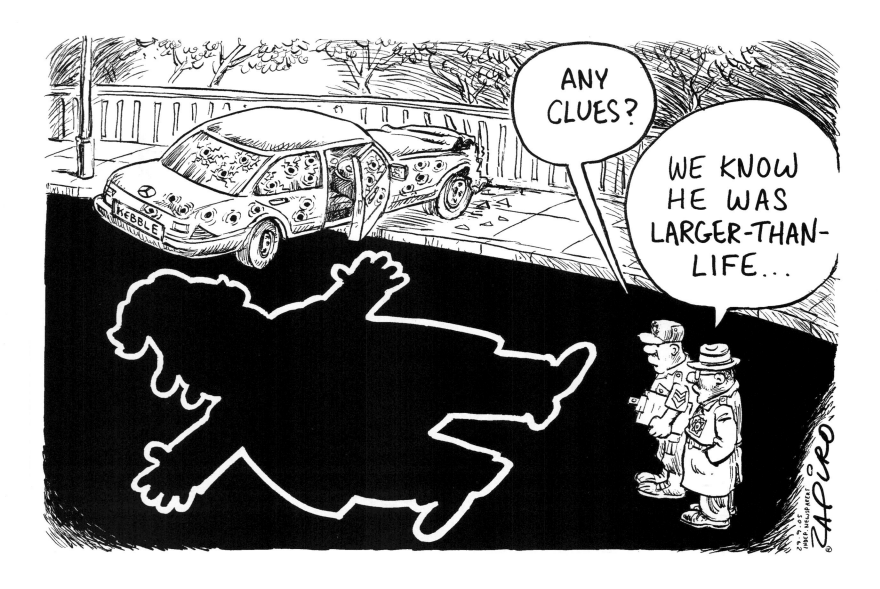

29 September 2005

Murder of controversial mining magnate Brett Kebble – philanthropist, promoter of black economic empowerment, backer of Zuma, tax evader – who faced pending charges of share manipulation and had stepped down from several top positions as his empire crumbled

8

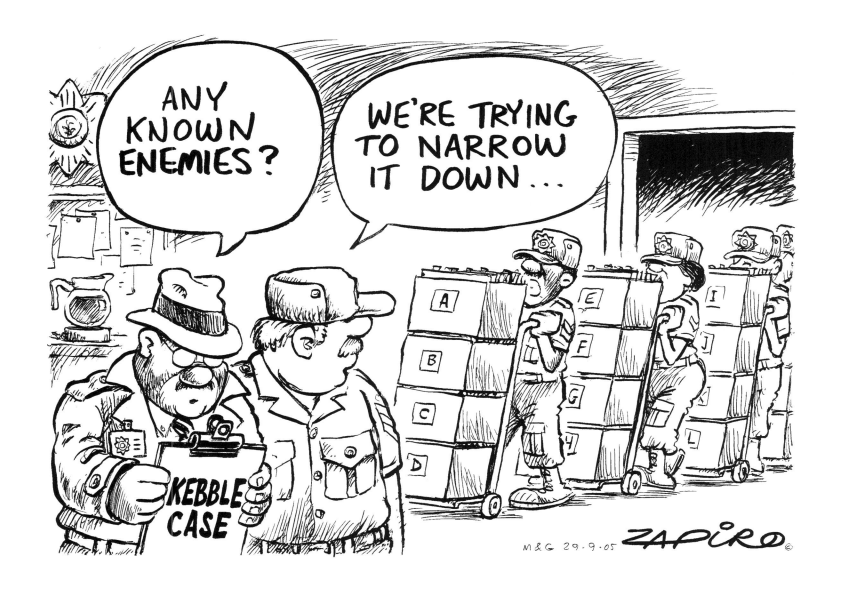

29 September 2005

A trail of dubious beneficiaries, cheated partners, aggrieved shareholders, political adversaries, criminal contacts

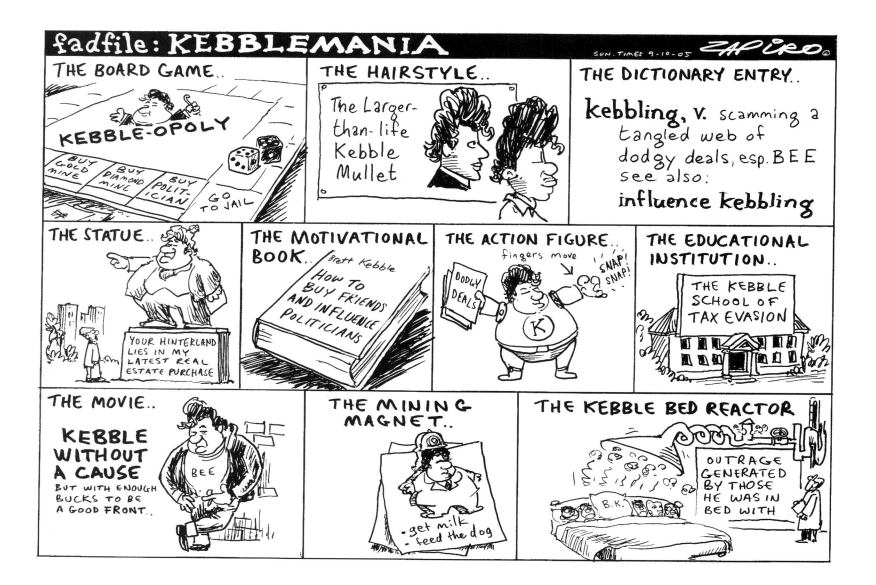

9 October 2005

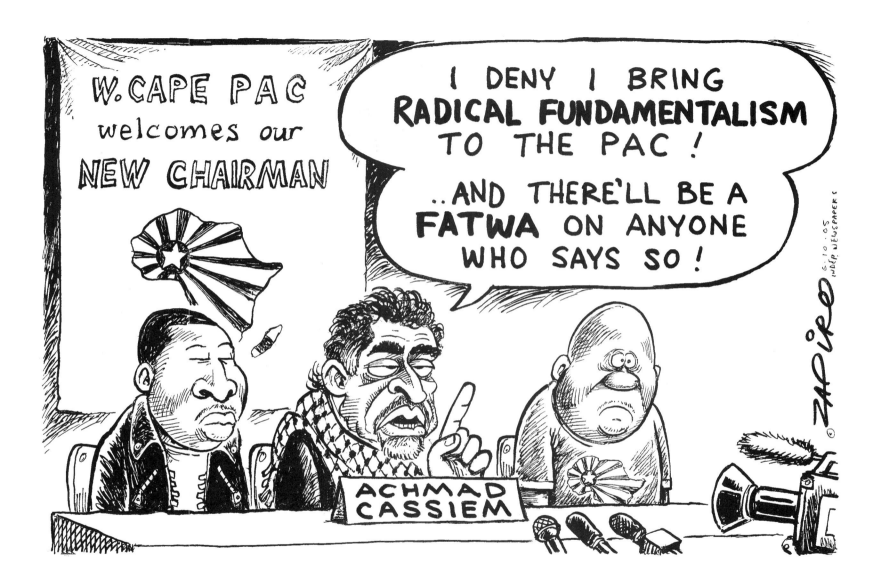

6 October 2005

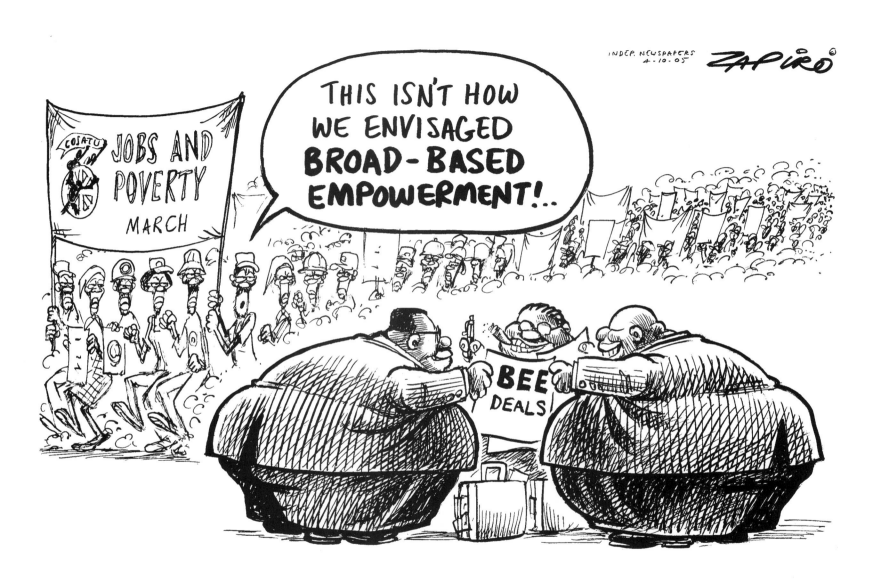

4 October 2005

INDEP. NEWSPAPERS 12·10·05 ZAPIRO ©

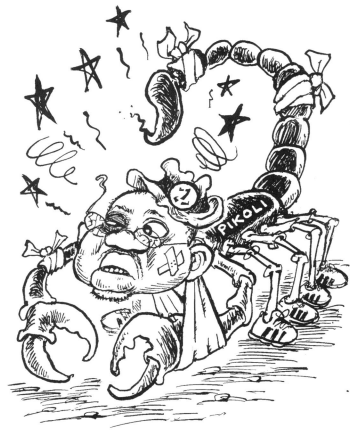

Scorpio (Oct-Nov)

Expect hostility this week. Beware of doing your job too thoroughly. Colleagues will invent conspiracy theories and try to destroy you. Even your boss says she'll disown you. Oh, and you're not paranoid— ...everyone **is** out to get you.

Whether the successful Scorpions unit remains independent will be decided at the Khampepe Commission, where police and intelligence big guns say the Scorpions are a law unto themselves and politically partisan. And there's no support from Justice Minister Brigitte Mabandla.

12 October 2005

16 October 2005

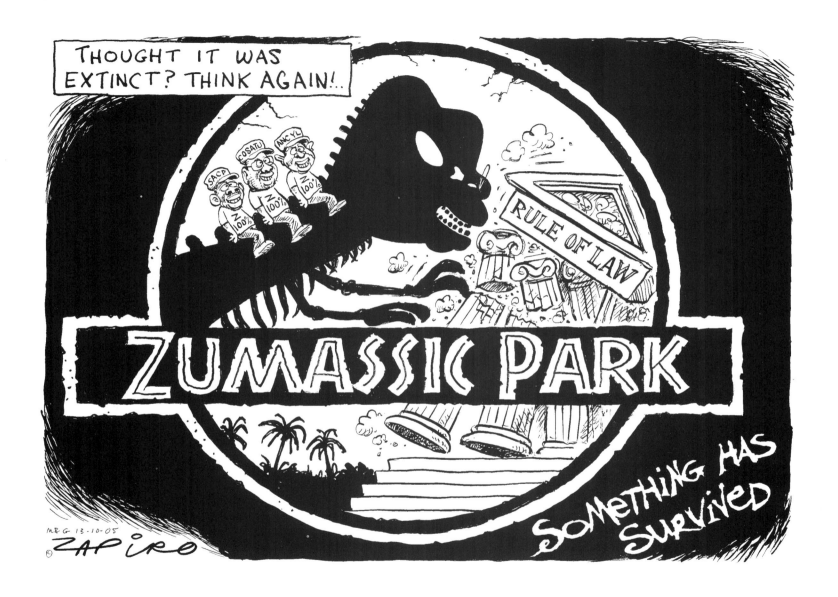

13 October 2005

Former deputy president Jacob Zuma appears on corruption charges. His unruly supporters and his questioning the court's legitimacy prompt a cabinet reprimand.

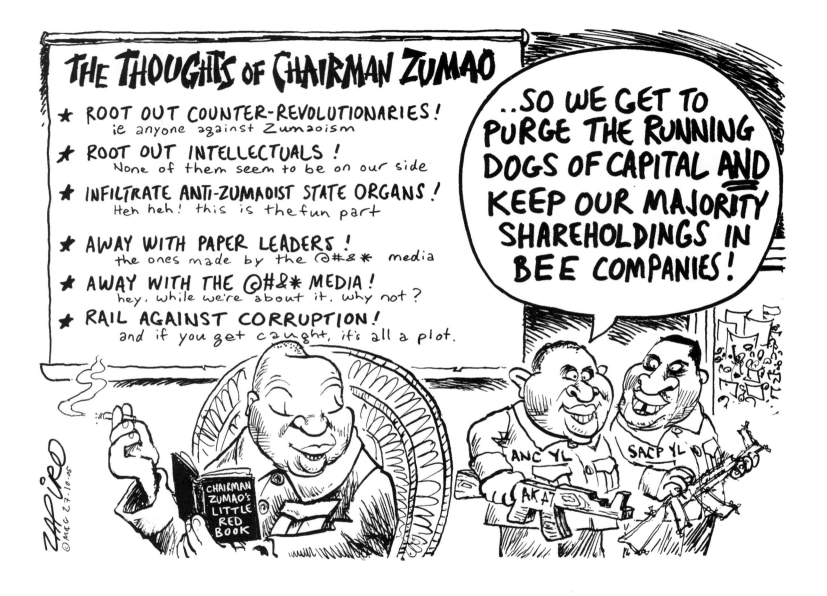

27 October 2005

Zuma quotes Mao Zedong, a veiled reference to Mbeki
as a 'paper leader' rather than the people's choice

16

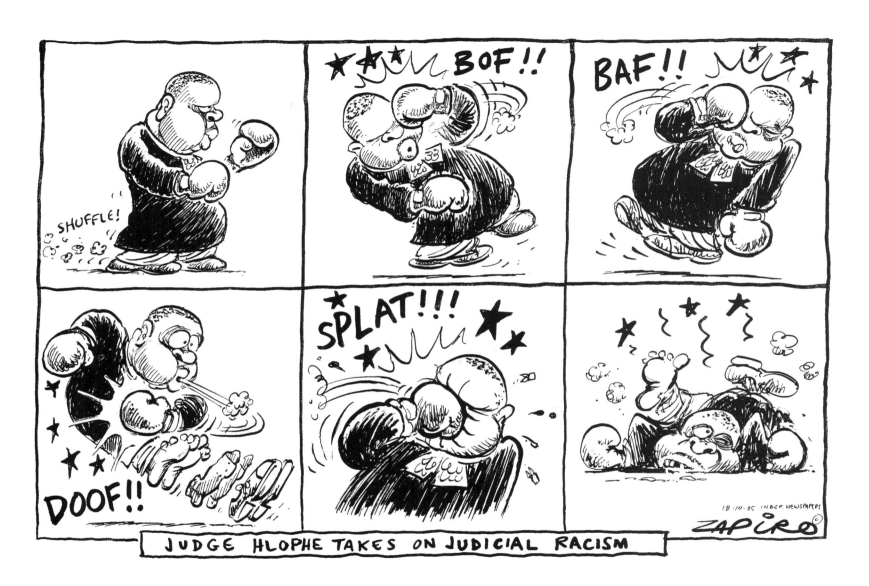

Racial tension in the Cape judiciary isn't helped when
the Cape Judge President makes racist remarks

ANIMAL HORROR MOVIES

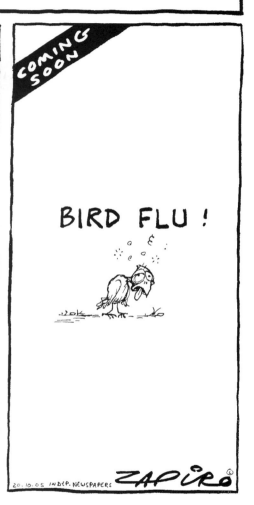

COMING SOON

BIRD FLU!

20.10.05 INDEP. NEWSPAPERS ZAPIRO

20 October 2005

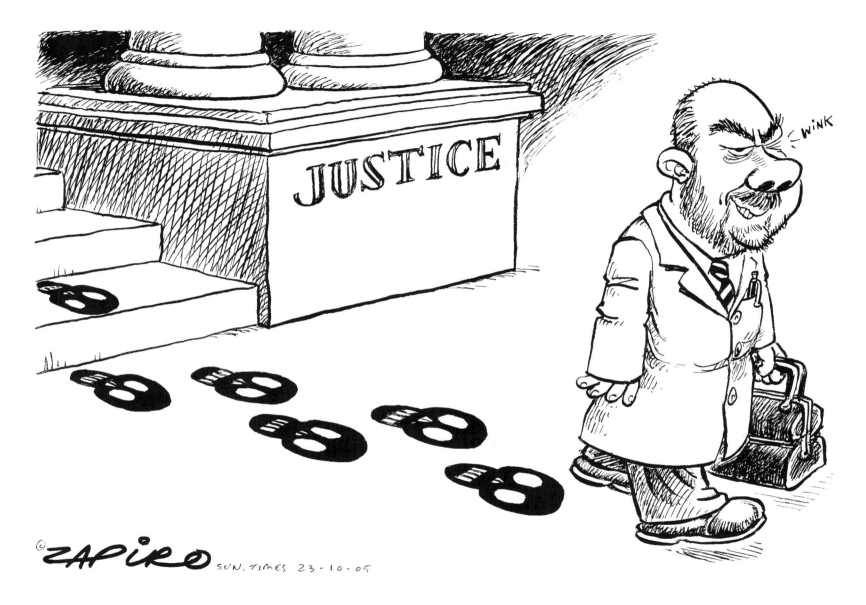

WINK

The state decides not to recharge apartheid chemical warfare kingpin Wouter Basson.
He'd been acquitted in 2002 of multiple charges including mass murder.

23 October 2005

19

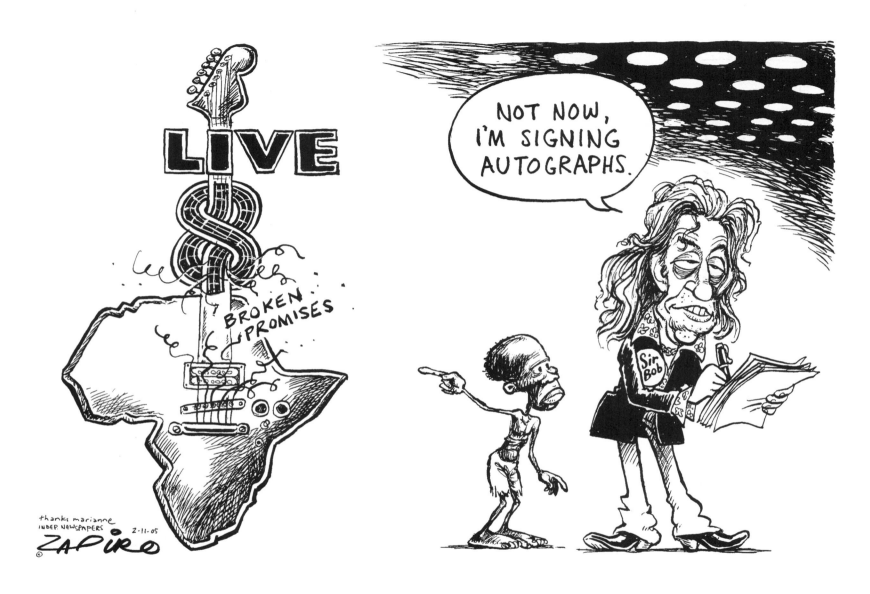

2 November 2005

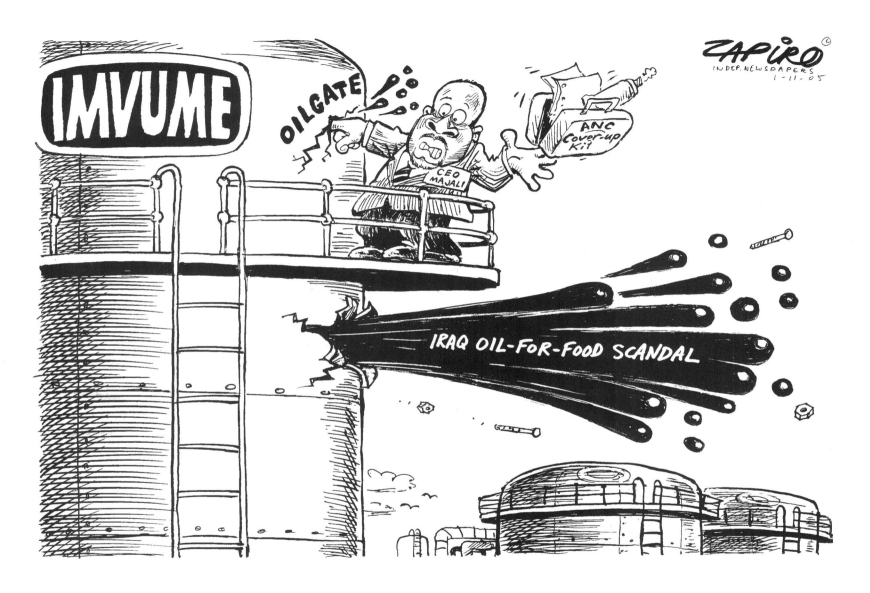

Already mired in the Oilgate scandal where state money went
to the ANC, Imvume's Sandi Majali is slammed in a UN
report for profiting from illegal deals with pre-war Iraq

1 November 2005

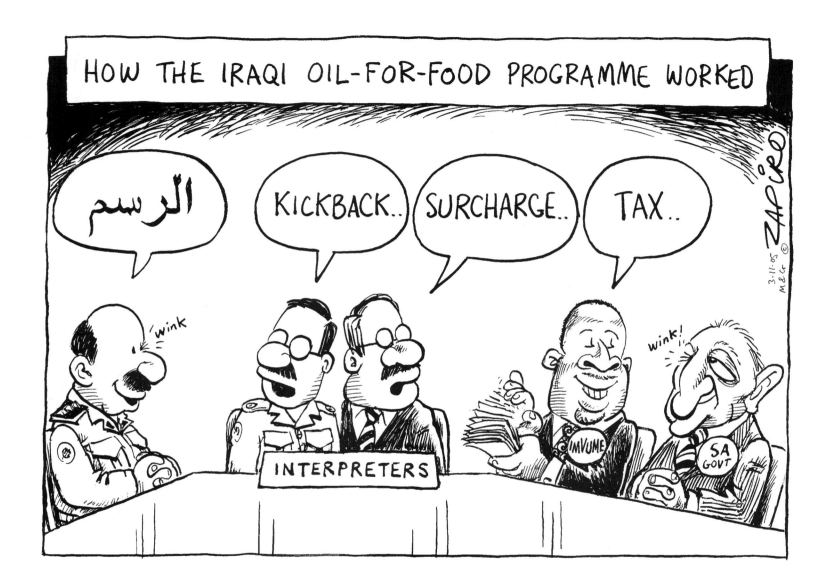

3 November 2005 'Surcharges' paid to Iraq to protect oil contracts held by ANC members

22

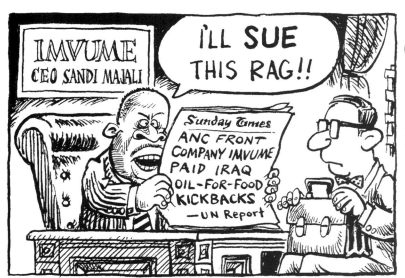

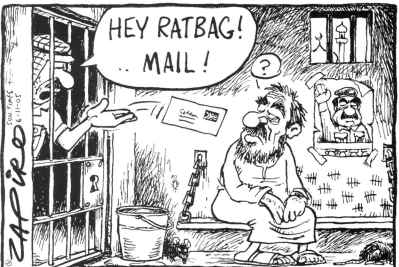

6 November 2005

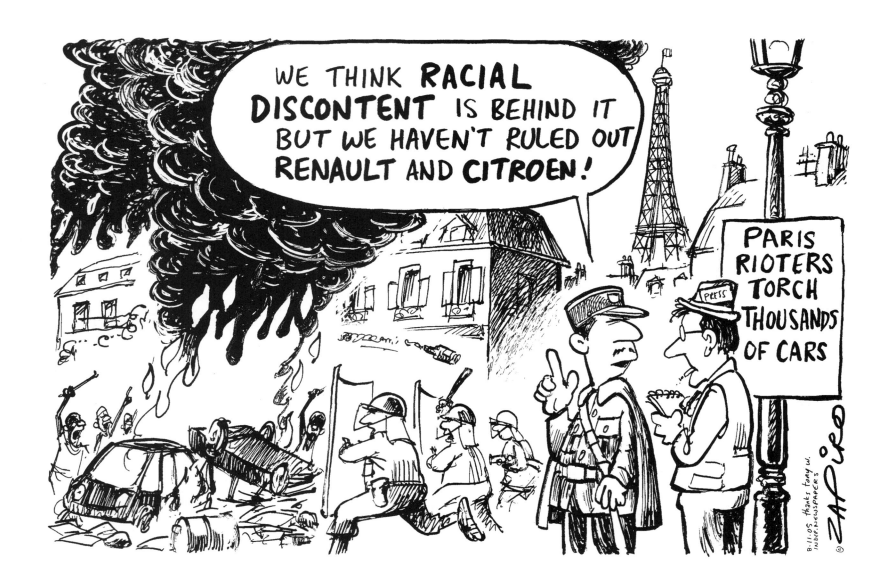

8 November 2005

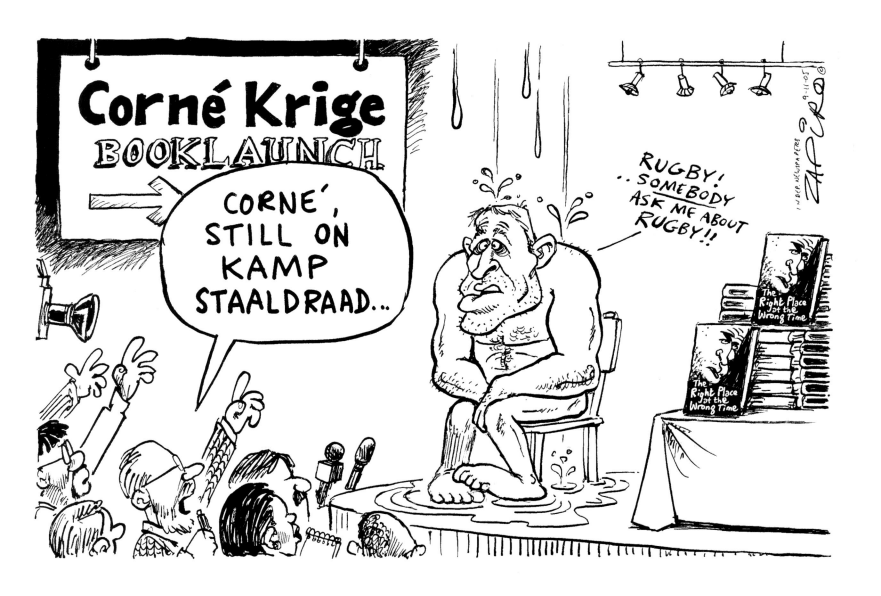

9 November 2005

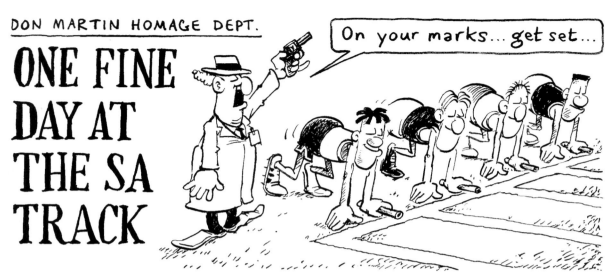

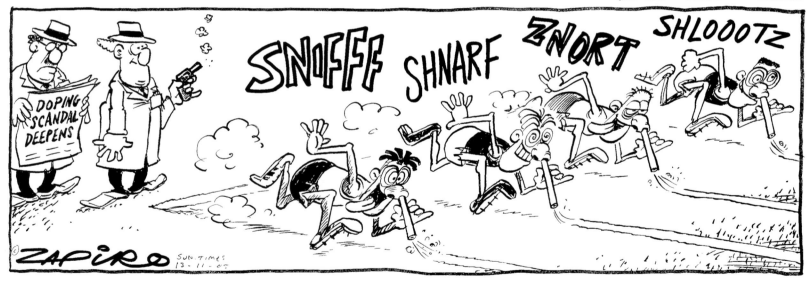

Three more runners suspended for doping

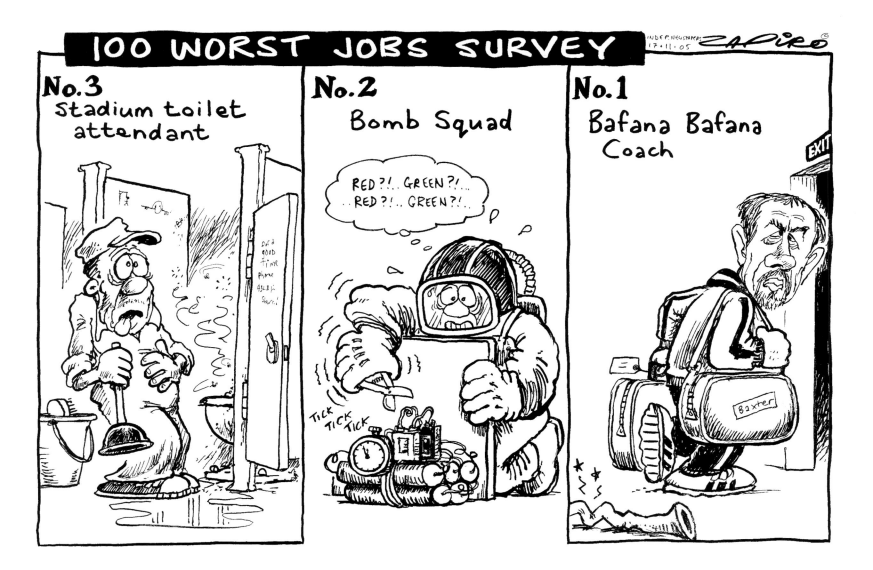

17 November 2005 13 coaches in 13 years, off-field crises, abysmal results. Stuart Baxter quits.

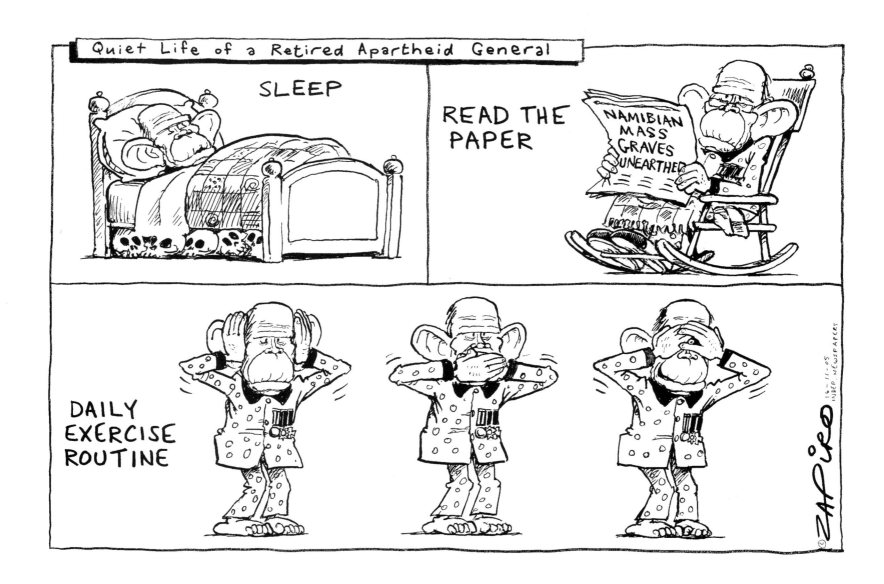

16 November 2005

Apartheid-era defence minister Magnus Malan denies knowledge
of mass graves found near a former SA military base

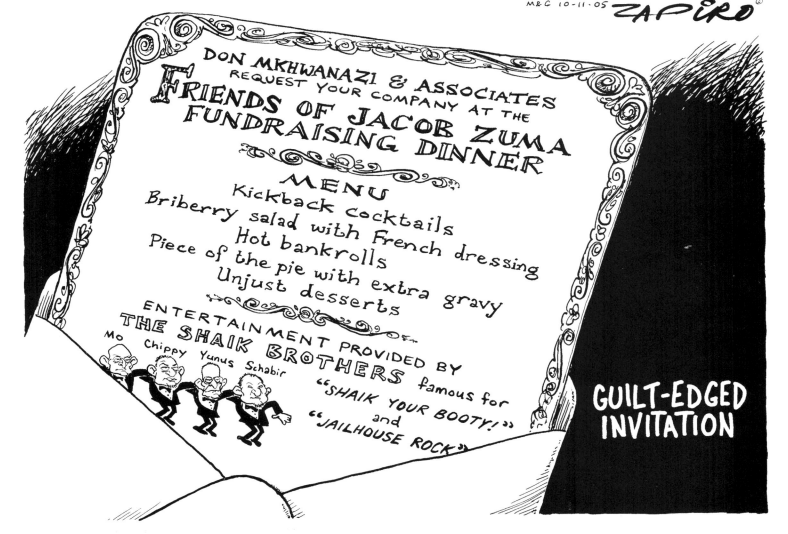

M&G 10-11-05 ZAPIRO

DON MKHWANAZI & ASSOCIATES
REQUEST YOUR COMPANY AT THE
FRIENDS OF JACOB ZUMA
FUNDRAISING DINNER

MENU
Kickback cocktails
Briberry salad with French dressing
Hot bankrolls
Piece of the pie with extra gravy
Unjust desserts

ENTERTAINMENT PROVIDED BY
THE SHAIK BROTHERS famous for

Mo Chippy Yunus Schabir

"SHAIK YOUR BOOTY!"
and
"JAILHOUSE ROCK"

GUILT-EDGED
INVITATION

10 November 2005

Ahead of Zuma's third court appearance for
corruption, his backers hold a fundraising party

29

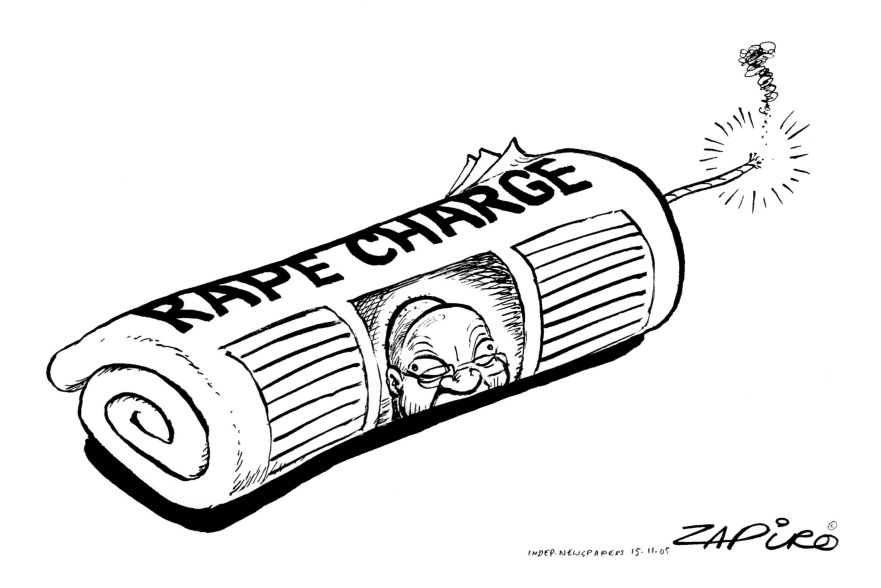

15 November 2005

Startling new allegation against Zuma that he
raped a woman who was a guest at his home

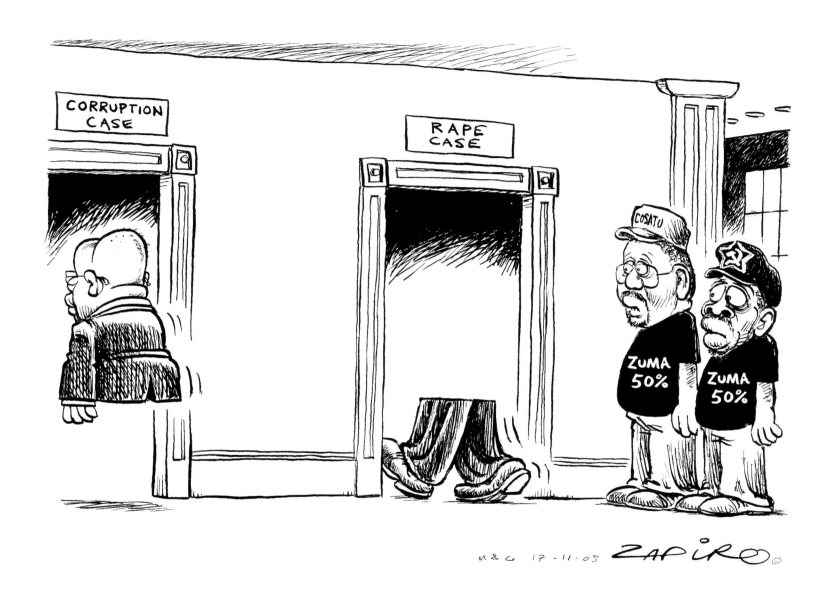

17 November 2005

Cosatu says it may reconsider support for Zuma over the rape charge

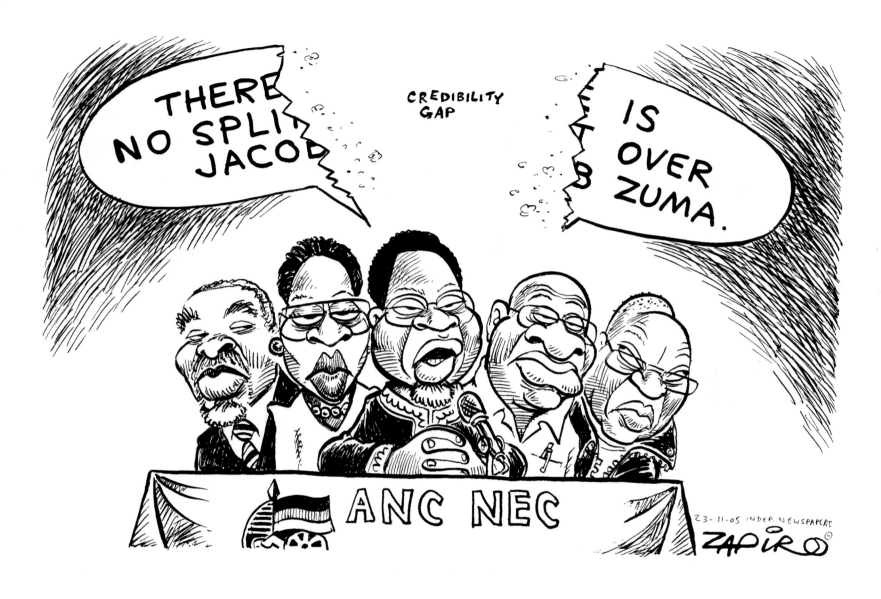

23 November 2005

After a meeting of the ANC's National Executive Committee,
a reassuring statement from Secretary-General Kgalema Motlanthe

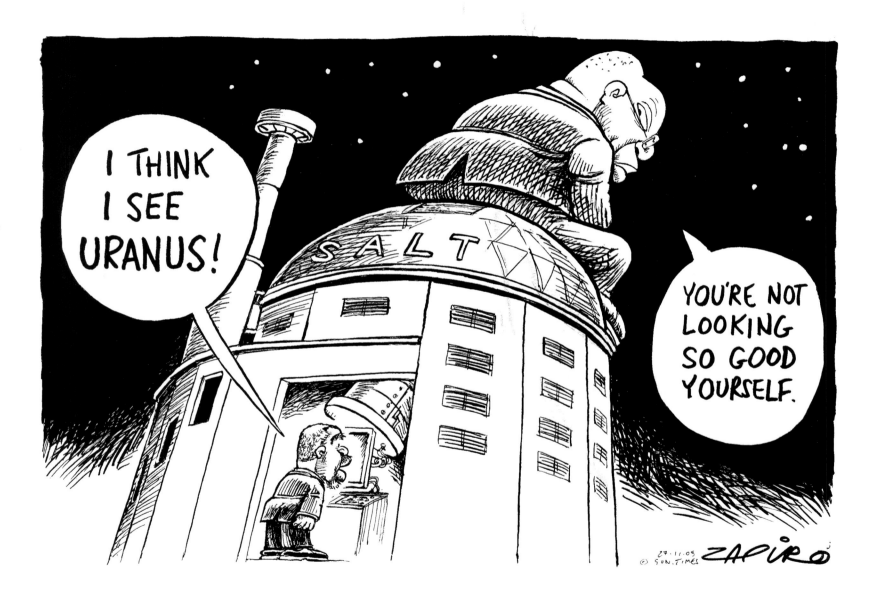

27 November 2005

President Mbeki inaugurates the huge Southern
African Large Telescope (SALT) in the Karoo

33

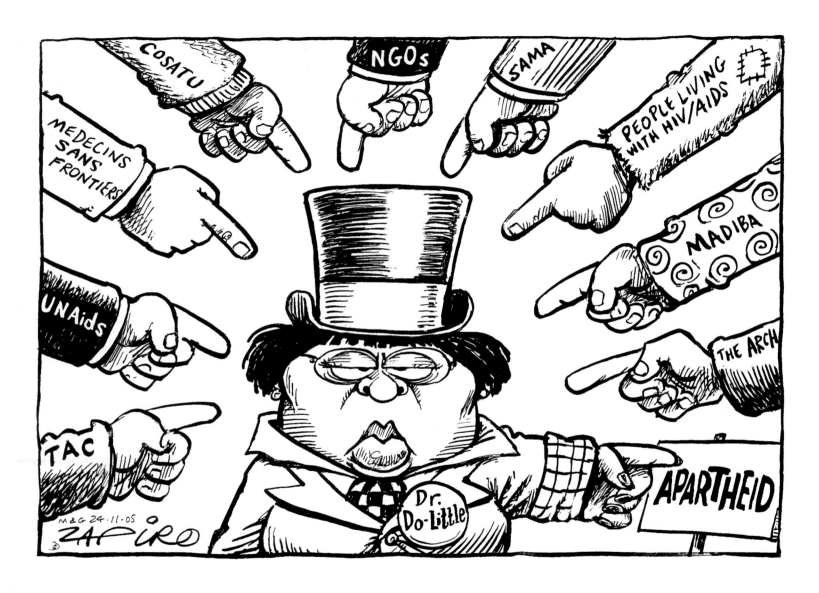

85% of South Africans needing anti-retrovirals aren't getting them, says a UN report. It's all because of the apartheid government's pre-1994 inaction on HIV/Aids, says the Health Department.

24 November 2005

34

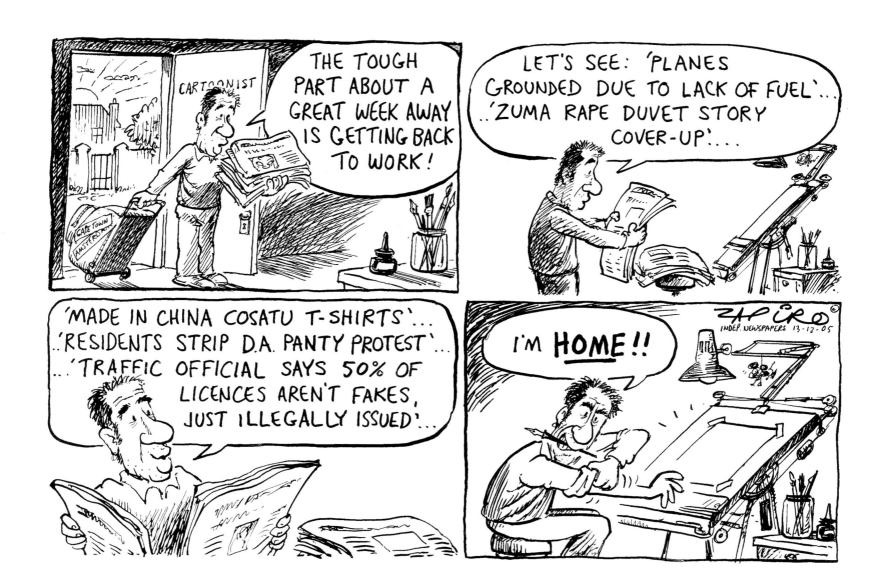

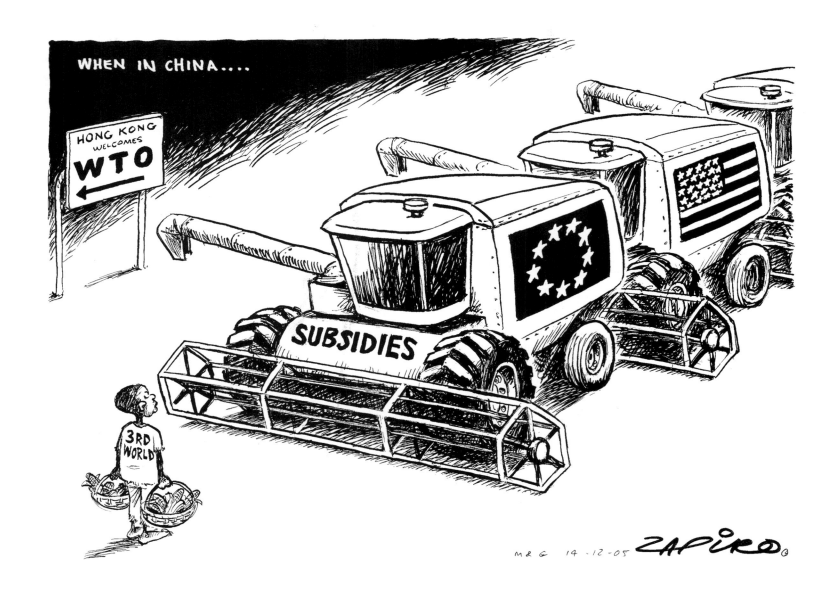

14 December 2005

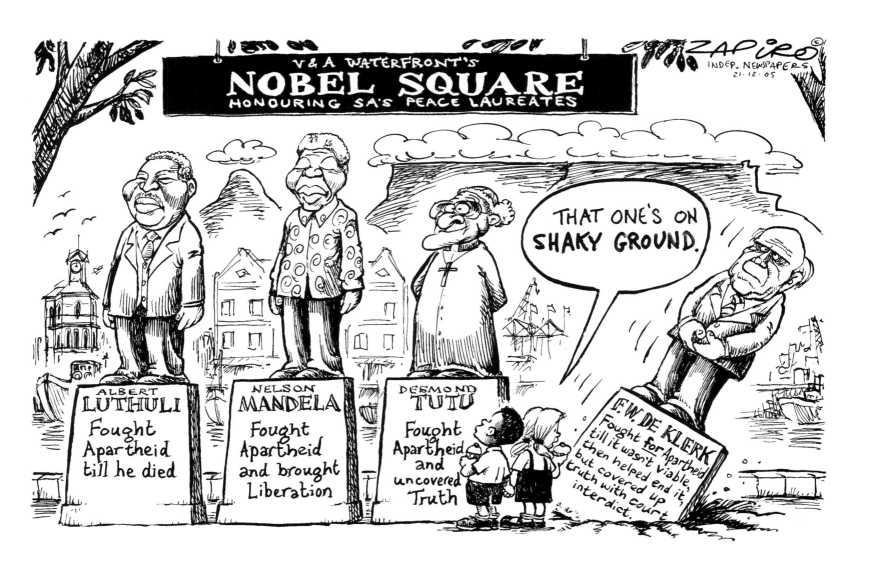

21 December 2005

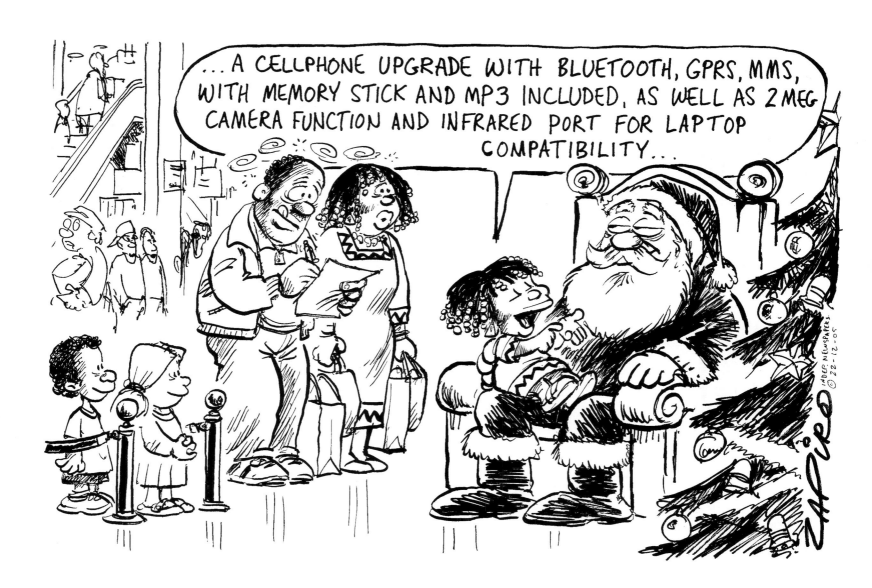

22 December 2005

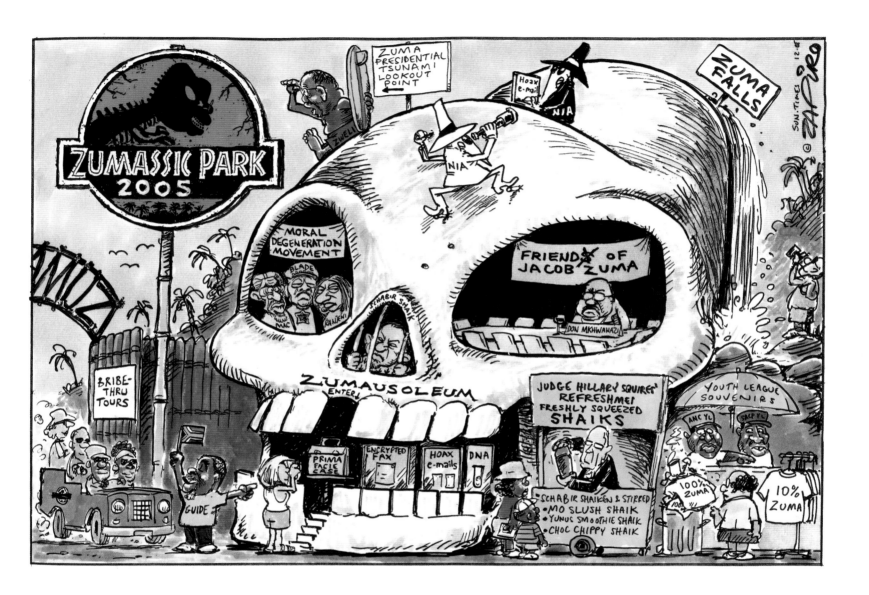

19 December 2005

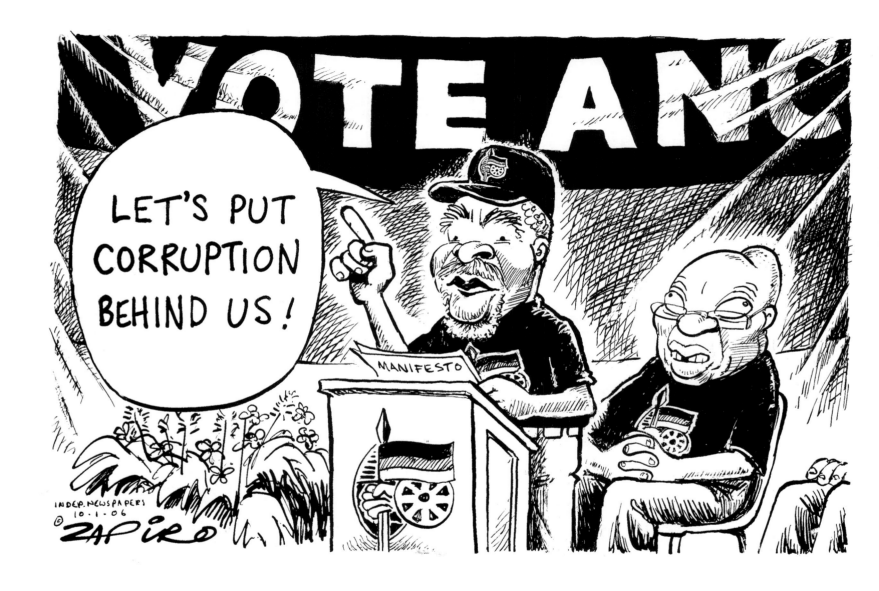

10 January 2006

Launching the ANC's local government
election campaign with a strong message

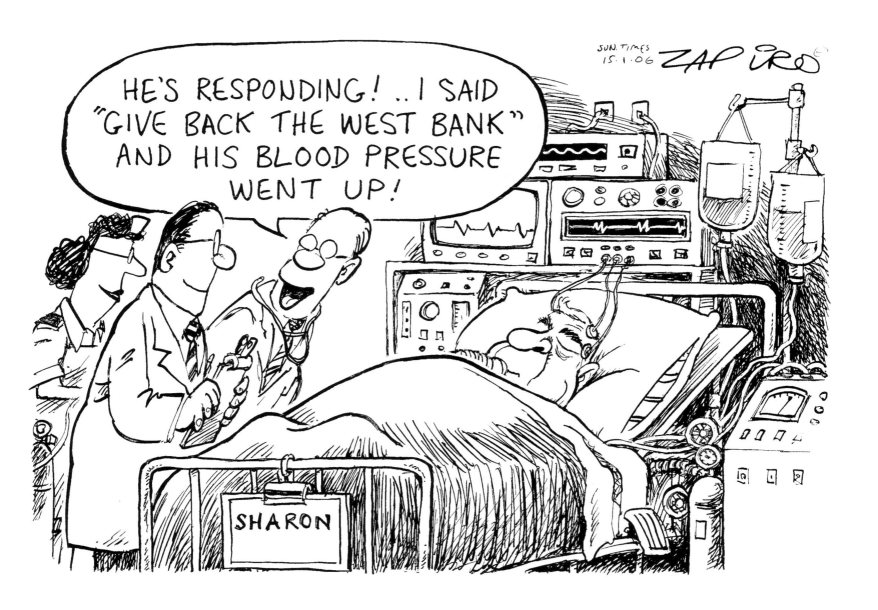

15 January 2006 Israeli Prime Minister Ariel Sharon, in a coma after a stroke, shows signs of brain activity

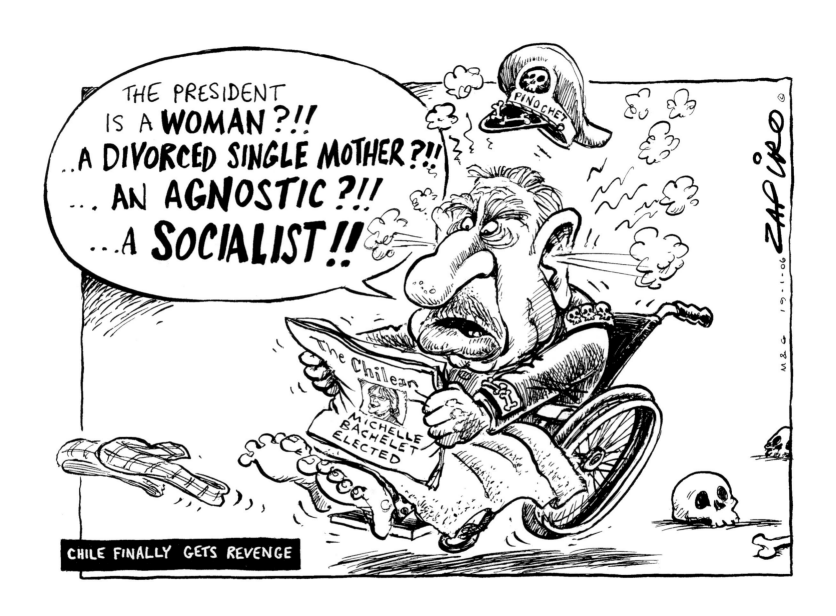

19 January 2006

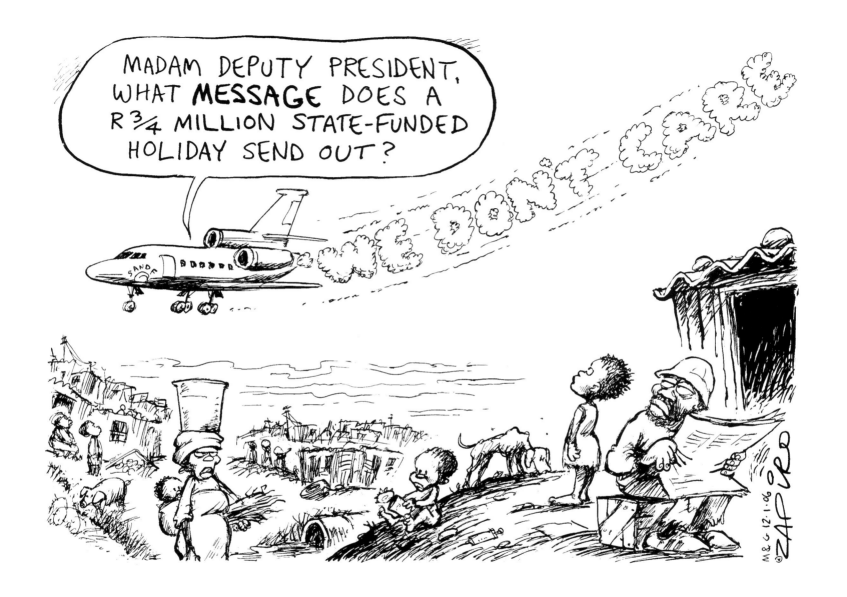

It seems Phumzile Mlambo-Ngcuka used an SA Air Force jet for a 'gravy plane' jaunt to Dubai that included her family, bodyguards and hangers-on

12 January 2006

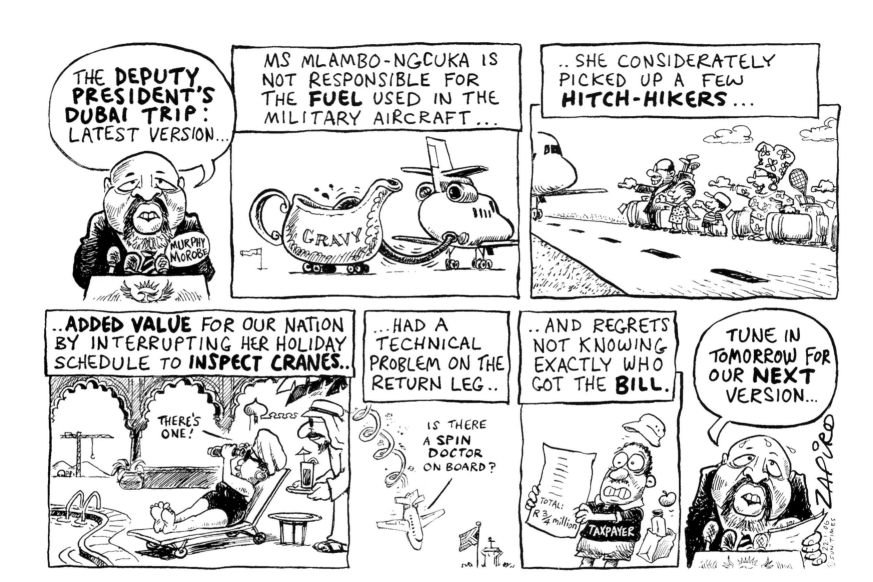

22 January 2006 Public outcry ensues. And so does a flurry of spin from the presidency.

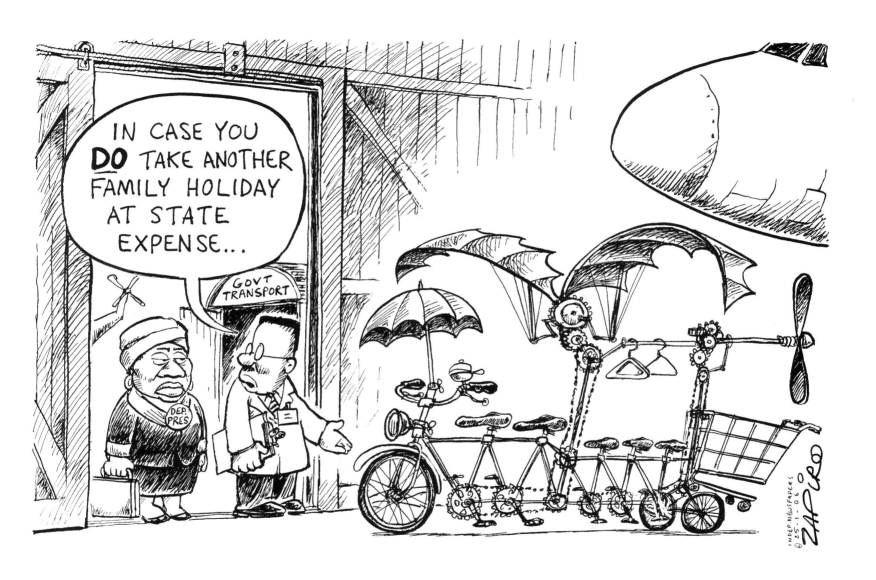

25 January 2006

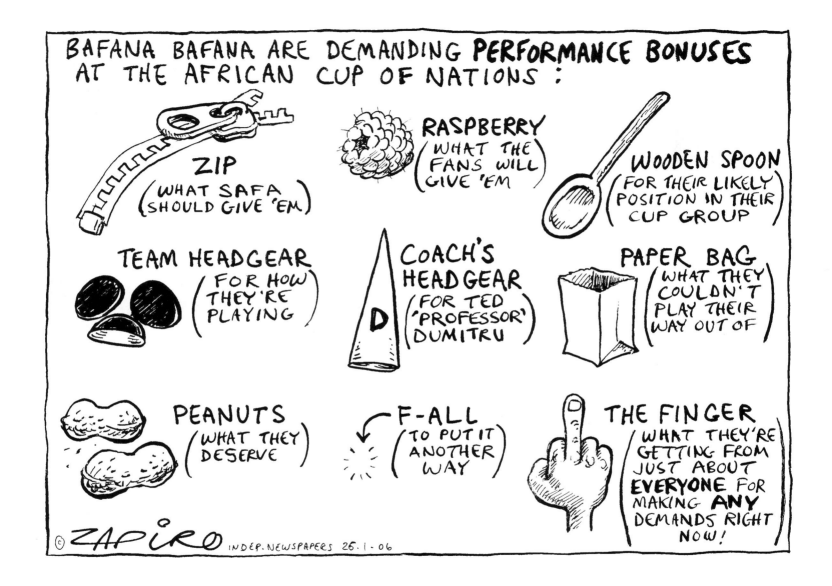

During a tournament where the former African champions will
end up losing all their matches without scoring even one goal

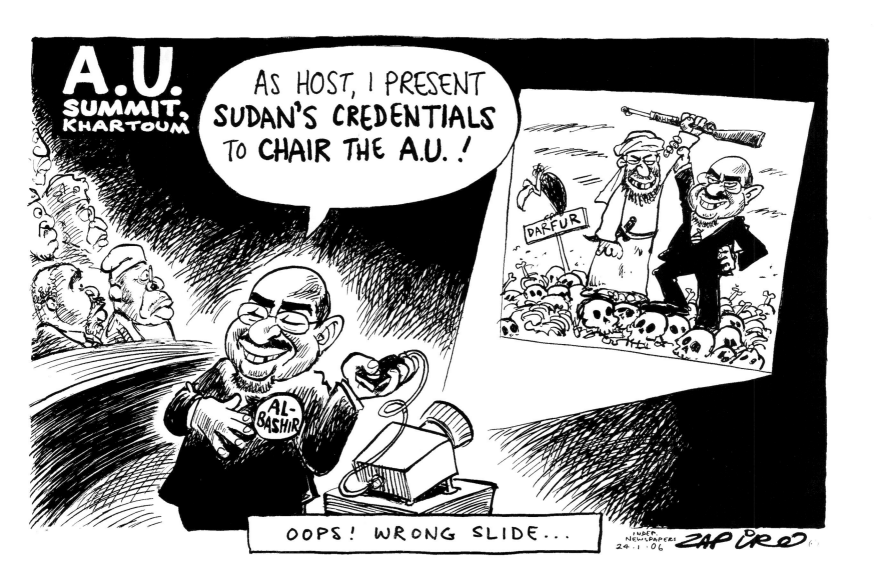

24 January 2006 High aspirations for a state accused of genocide

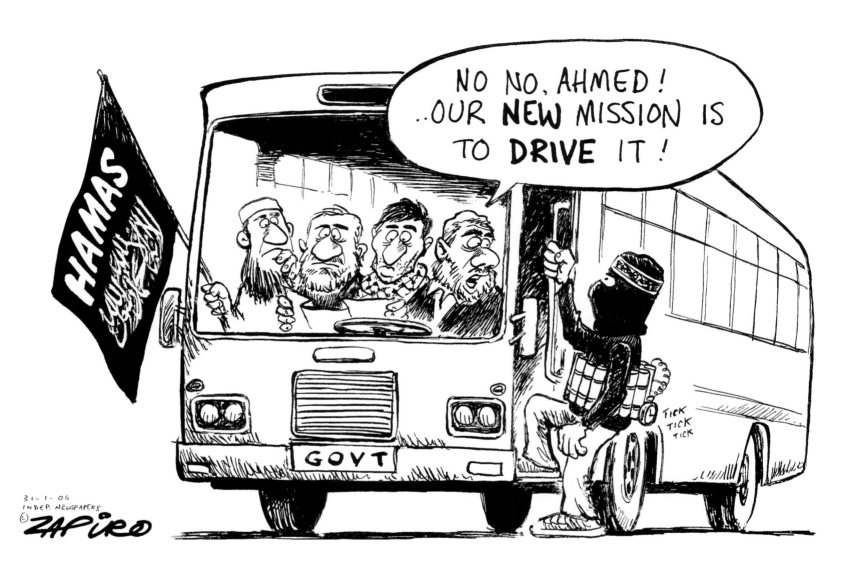

31 January 2006

Militant Islamists Hamas win a majority in the
Palestinian Parliament, surprising even themselves

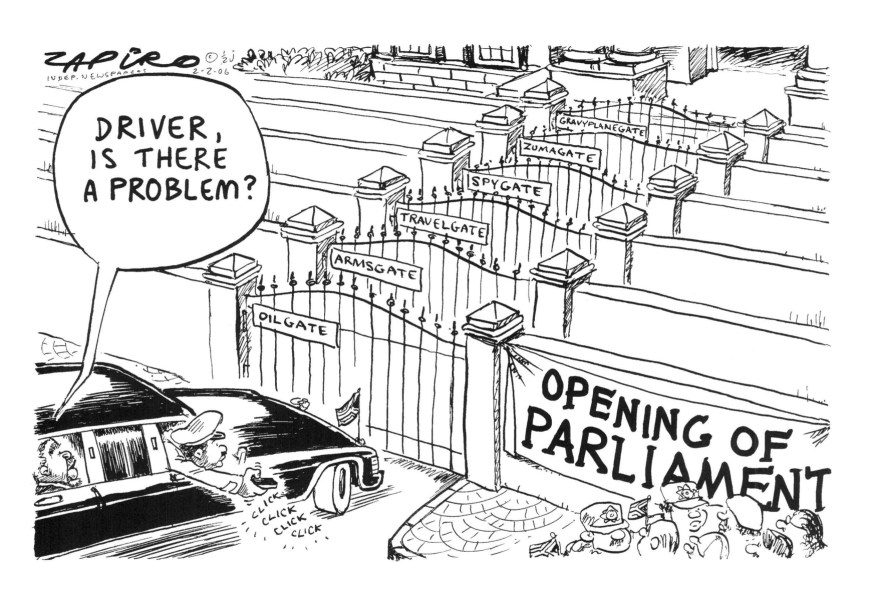

2 February 2006

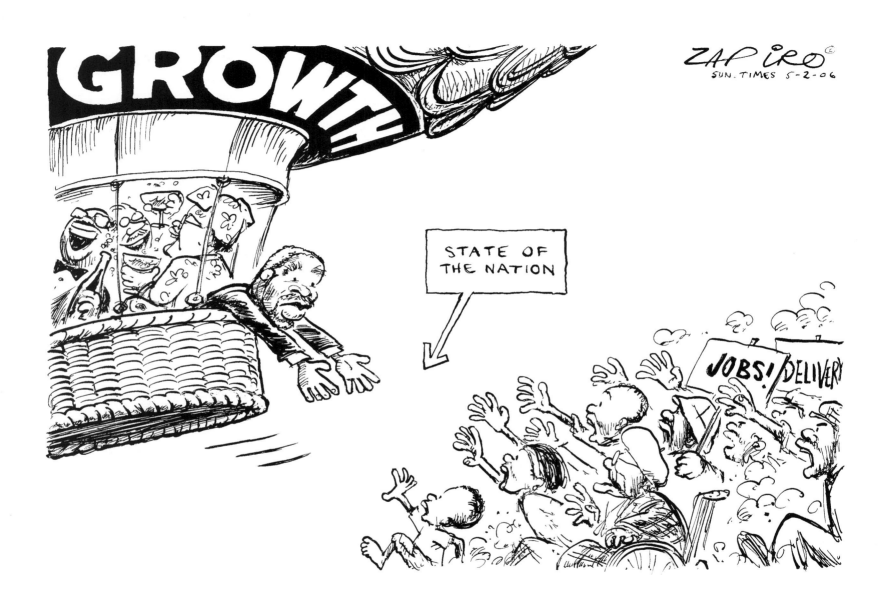

5 February 2006

In his State of the Nation address, President Mbeki pushes the new
Accelerated Shared Growth Initiative for South Africa (Asgi-SA)

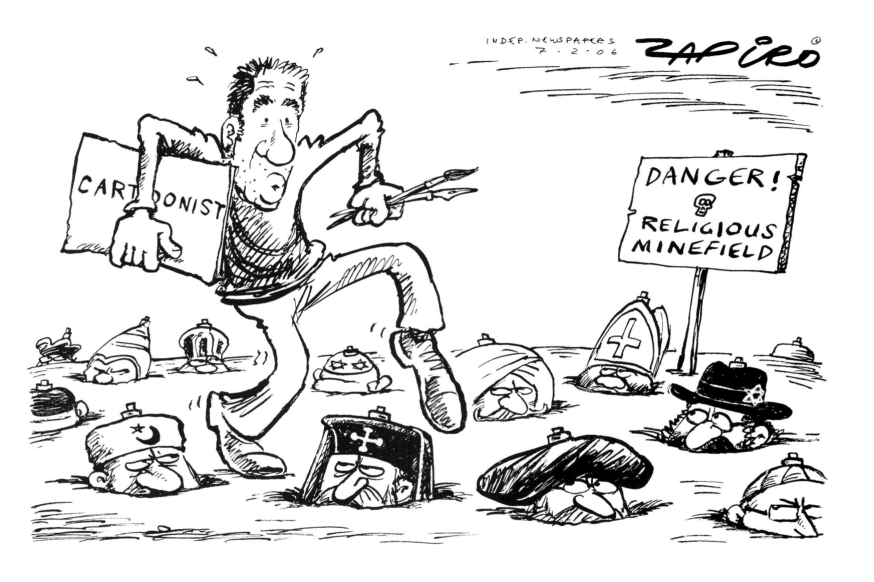

A Danish newspaper publishes cartoons flouting the Muslim injunction
against the depiction of the Prophet Mohammed, sparking global
Islamic fury, riots, deaths and the torching of embassies

7 February 2006

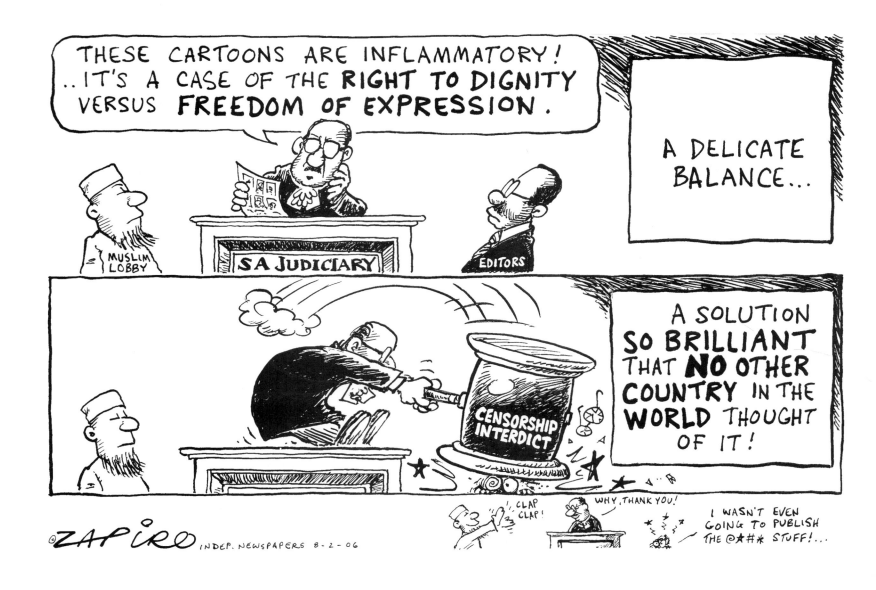

8 February 2006 Muslim clerics win a court order barring publication of the cartoons

WEAPON OF MASS DESTRUCTION

9 February 2006

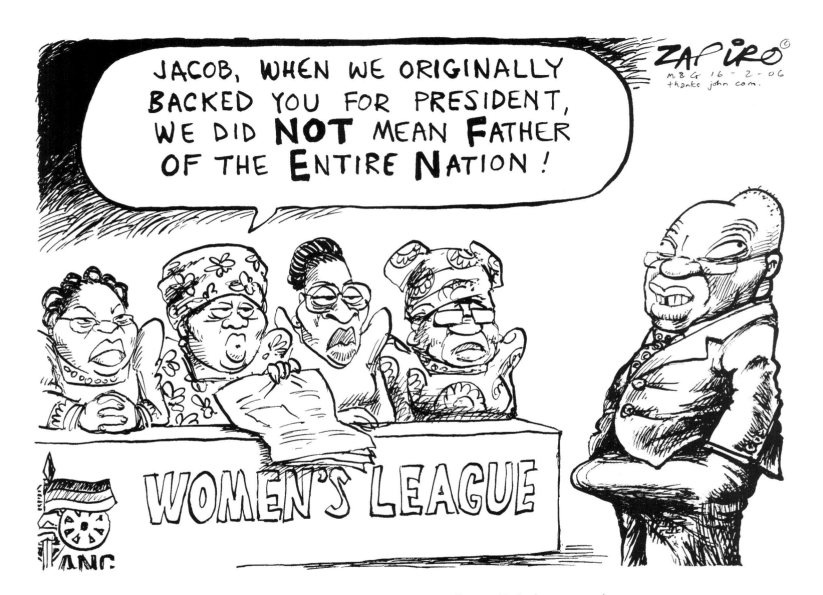

He has three wives, an ex-wife and many offspring. He had unprotected sex with his rape accuser. Now a judge recuses himself from Zuma's rape trial because Zuma fathered the judge's nephew.

16 February 2006

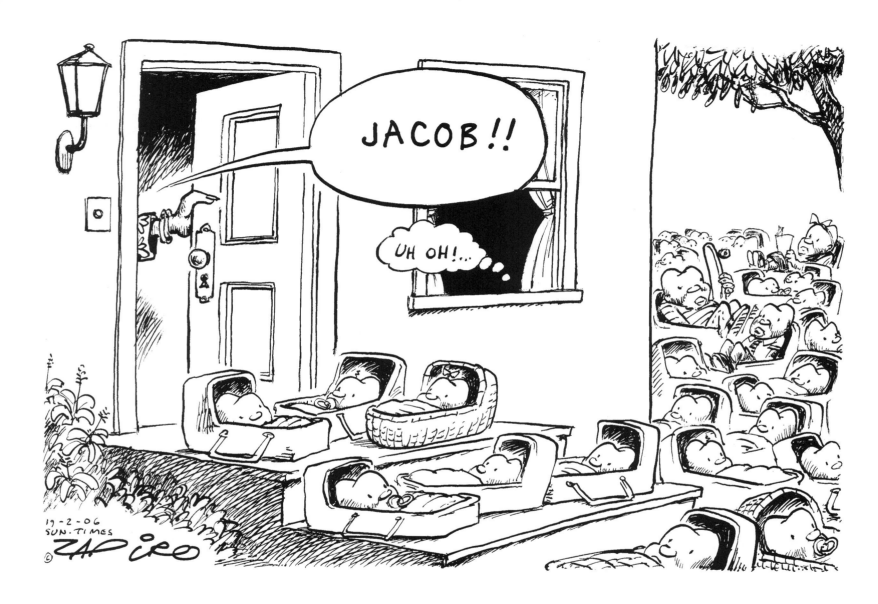

19 February 2006

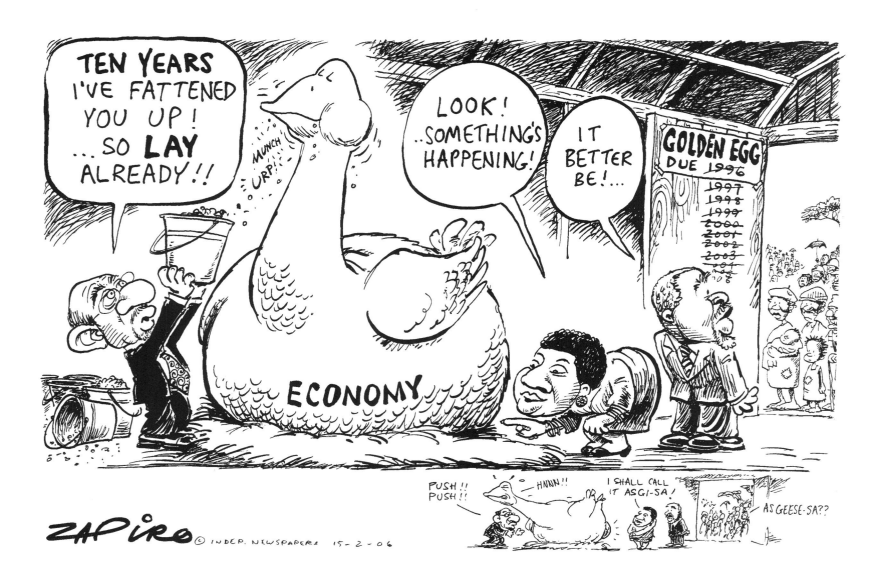

15 February 2006 The Budget. The economic upturn hasn't really filtered down.

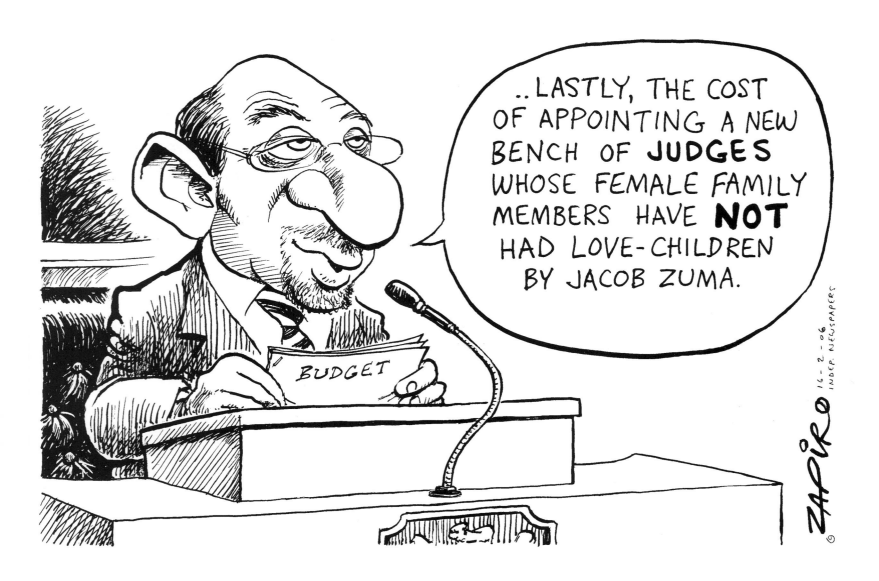

16 February 2006

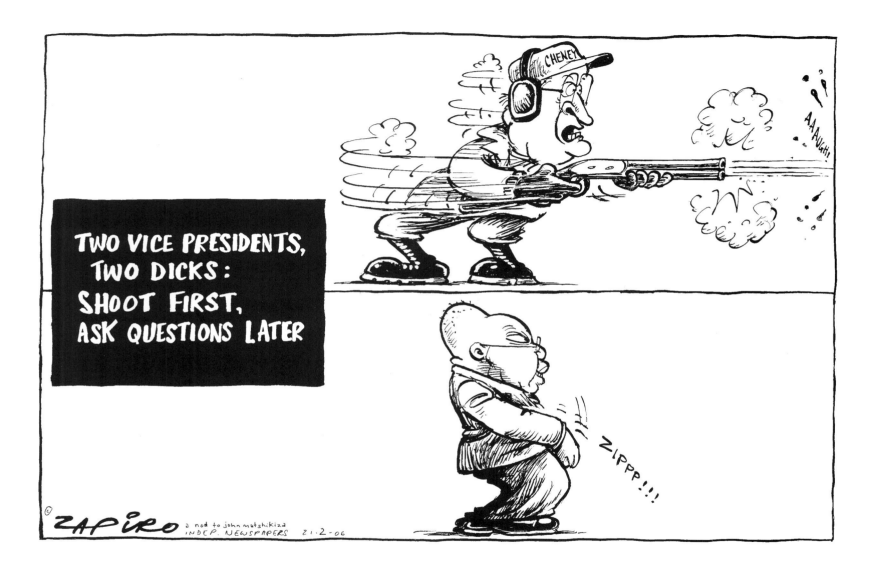

21 February 2006

Dick Cheney accidentally shoots a hunting companion

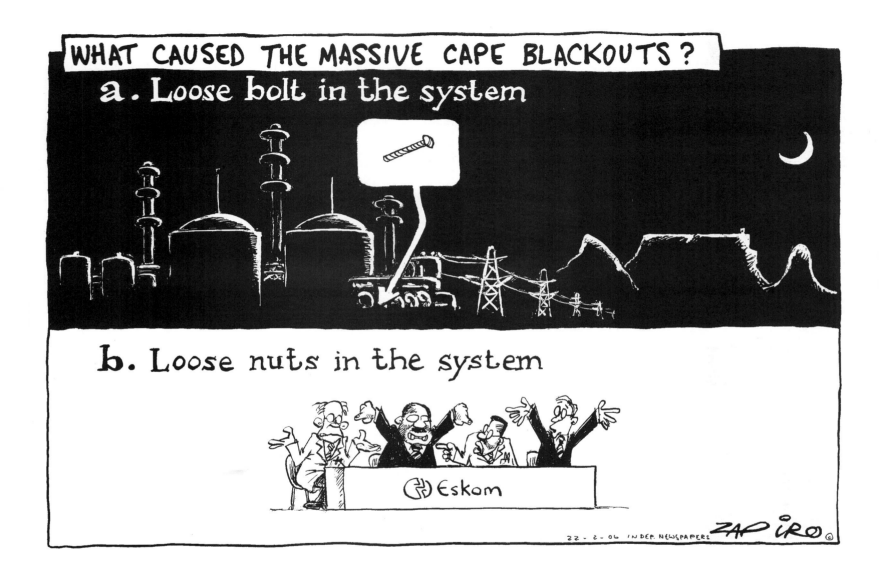

22 February 2006

A bolt that damaged a Koeberg nuclear generator is the official explanation for crippling power cuts. Ahem … how about poor planning and bad management.

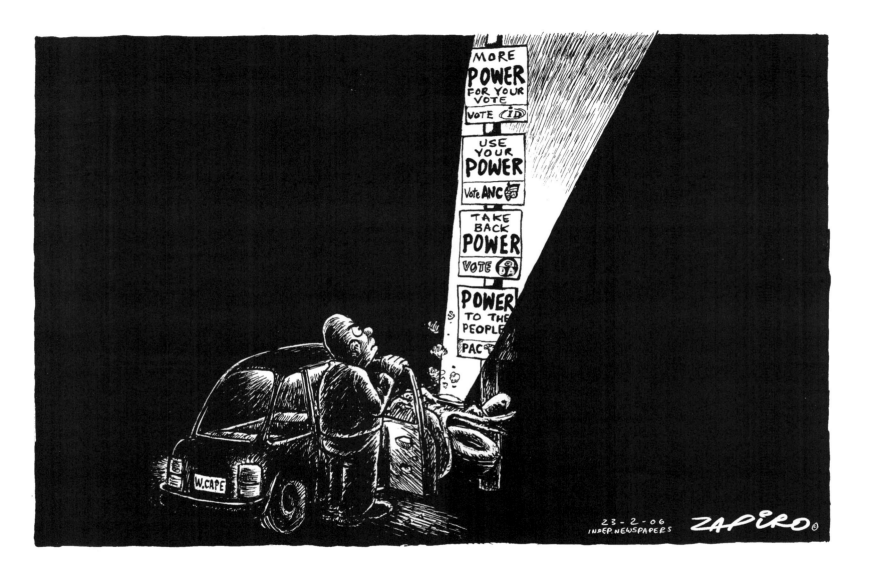

23 February 2006 The power cuts come in the run-up to the local government election

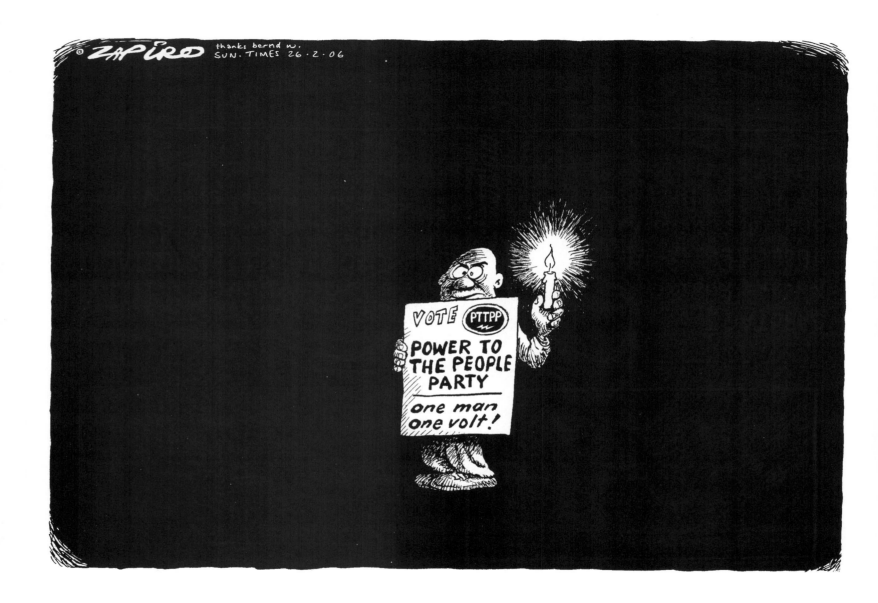

26 February 2006

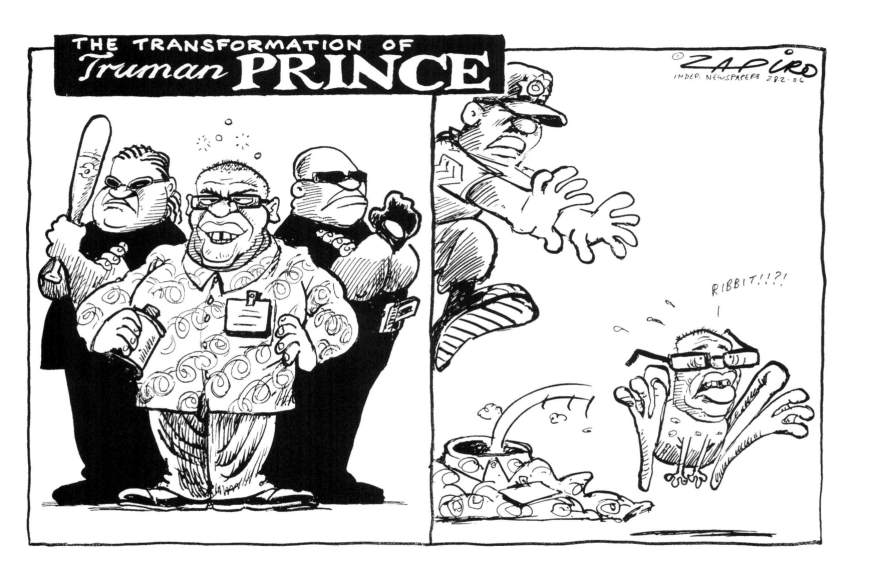

Just days before the municipal poll, notorious Beaufort West municipal manager
Truman Prince is finally sacked and, after another drunken incident, will face assault charges

28 February 2006

Party	Description	Party	Description
ACDP	Anti-Constitution Dogma Party	MF	Microscopic Front
ANC	Absolutely No Contest	NADECO	Newly Absconded Deserters Escaping the Clutches Of...
Azapo	Addled, Zero-Ability, Politically Outdated	NNP	Nearly Nonexistent Party
DA	Darkies Absent	PAC	Prickly And Clueless
FA	F-all	UDM	Uninspired Dead Movement
ID	Impetuous DeLille	UIF	Unemployment Insurance Fund (huh??!)
IFP	Increasingly Feeble Party	VF Plus	Volk Frustrated Up to Here!

1 March 2006

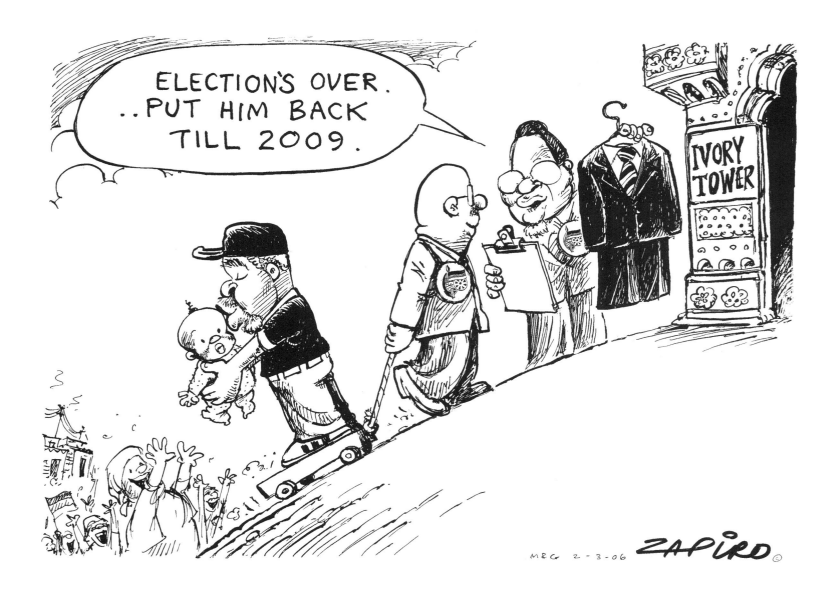

2 March 2006

While campaigning, he's been more informal and accessible than usual

BEST ACTOR:
Thabo Mbeki for "Man of the People"
(or "I'll Put On a T-Shirt For 15 Minutes
But Keep the Limo's Engine Running")

BEST PERFORMANCE IN A SUPPORTING ROLE:
Patricia de Lille
for "Balance of Power"

BEST NON-SUPPORTING ROLE:
Khutsong residents
for "1% Poll"

BEST SONG:
Pretoria Name-change Committee
for "Way Down Upon
the Tshwane River"

BEST SCORE:
ANC for "70%"

BEST SHORT FILM:
DA in
"Vision of Glory"

BEST GANGSTER MOVIE:
"The Return of
Truman Prince"

BEST ROMANTIC COMEDY:
Jacob Zuma for
"All My Children"

LIFETIME NON-ACHIEVEMENT AWARD:
Mangosuthu Buthelezi

R.I.P.
IFP

BEST SPECIAL EFFECTS:
Eskom
for "Cape Town"

BEST SCIENCE FICTION SCREENPLAY:
Alec Erwin for
"The Loose Bolt Conspiracy"

BEST EDITING:
Alec Erwin for
"I Never Said That!"

Minister Alec Erwin's pre-election bombshell: the loose bolt that caused the power cuts
was sabotage! Now he denies he said it, instead blaming 'human instrumentality'. Huh?

CAPE BLACKOUTS — A GLOSSARY OF TERMS

ZAPIRO
INDEP. NEWSPAPERS 8·3·06

NECESSARY LOAD SHEDDING

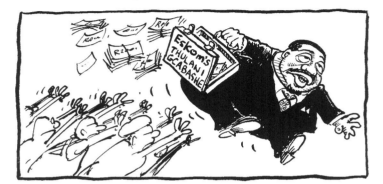

POWER OUTAGE

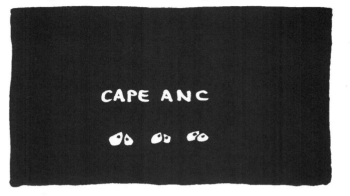

CAPE ANC

SABOTAGE
No-one knows
about this except
one loose wing-nut
in the system (pictured)

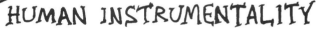

HUMAN INSTRUMENTALITY
No-one knows what this
means except same wing-nut.

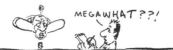

MEGAWHAT??!

8 March 2006

67

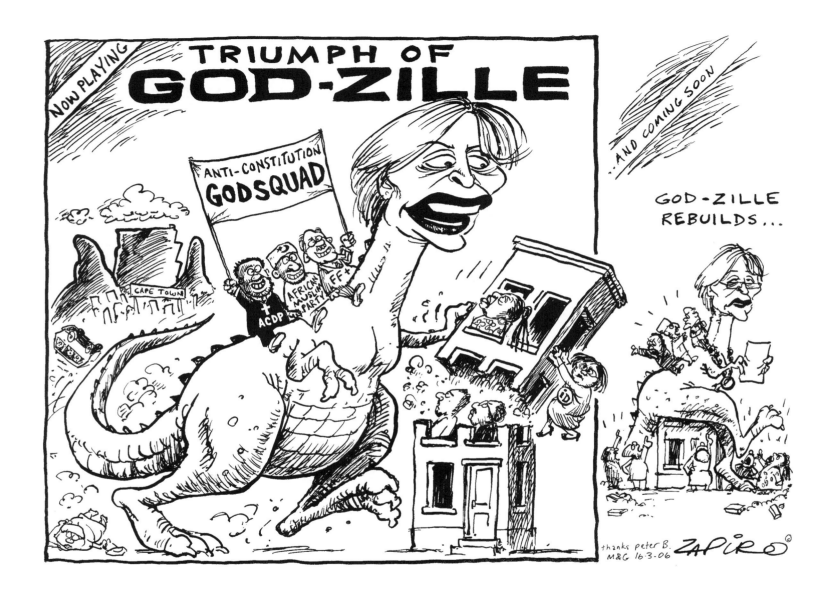

16 March 2006

A lengthy battle for the Cape metro, at last narrowly won by tough Democratic Alliance mayoral candidate Helen Zille in an unlikely coalition with conservative parties

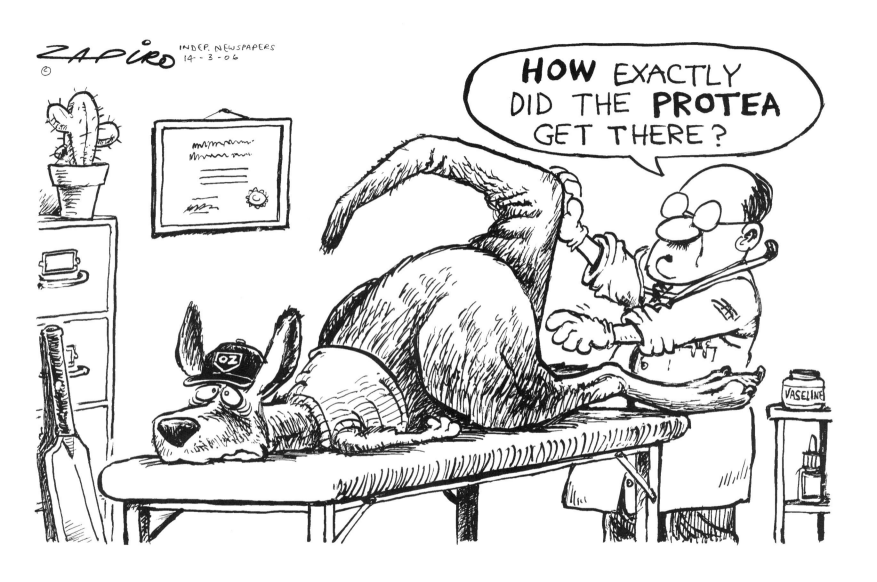

14 March 2006

In a series-clinching game, a one-day international world record total by world champs
Australia lasts only long enough to be blitzed by SA's new world record score

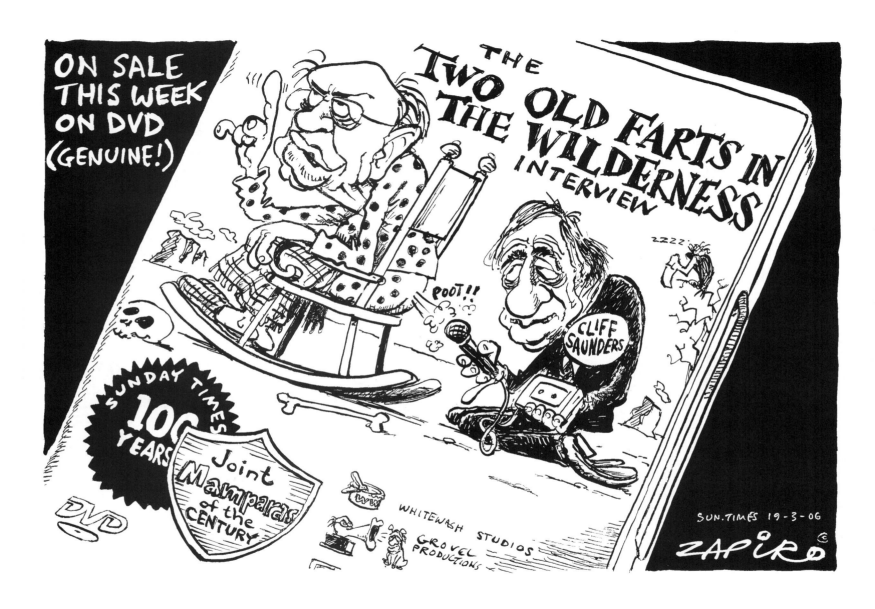

19 March 2006

Surprise surprise, no TV station wants apartheid propagandist Cliff Saunders' exclusive
interview with PW Botha at his Wilderness home, so this gem is released on DVD

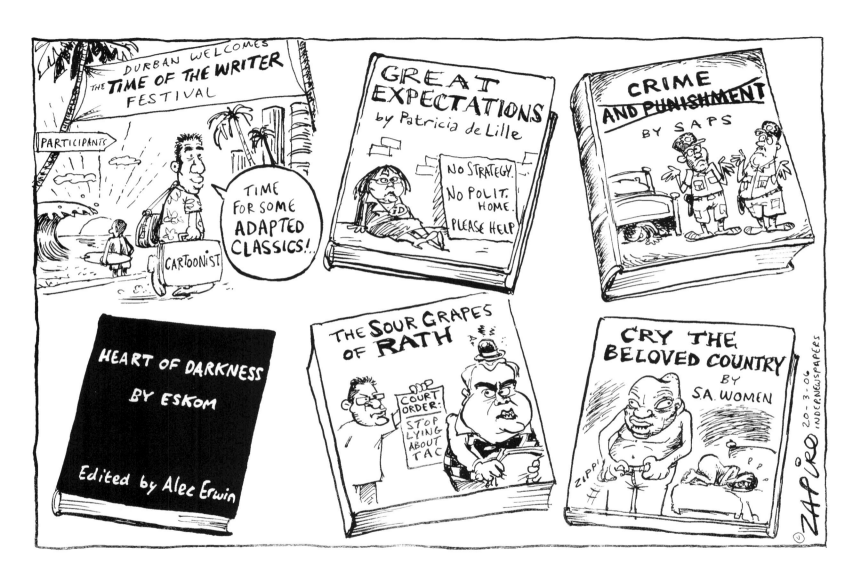

20 March 2006

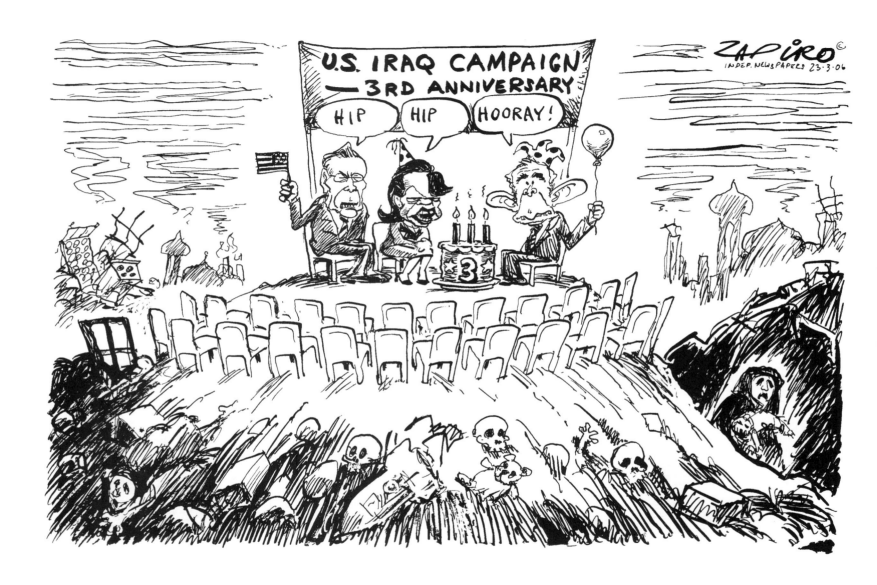

23 March 2006

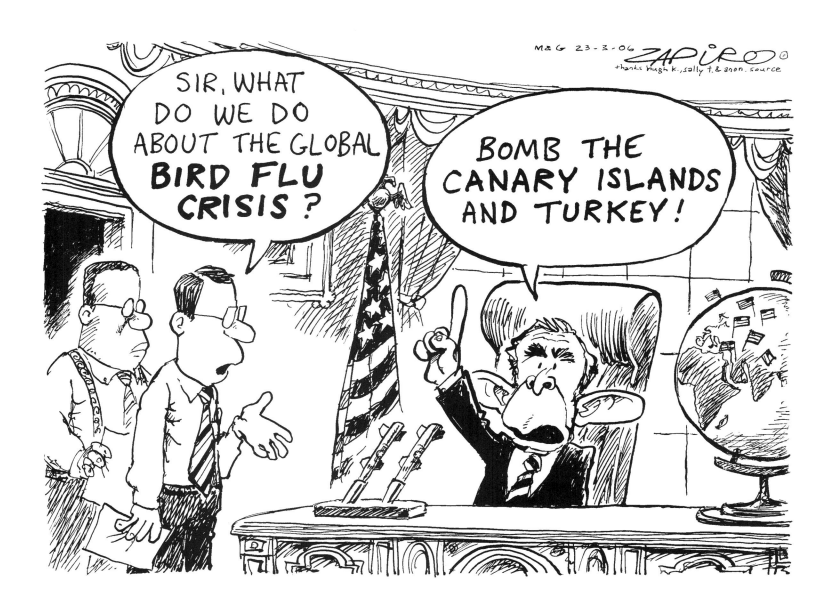

23 March 2006

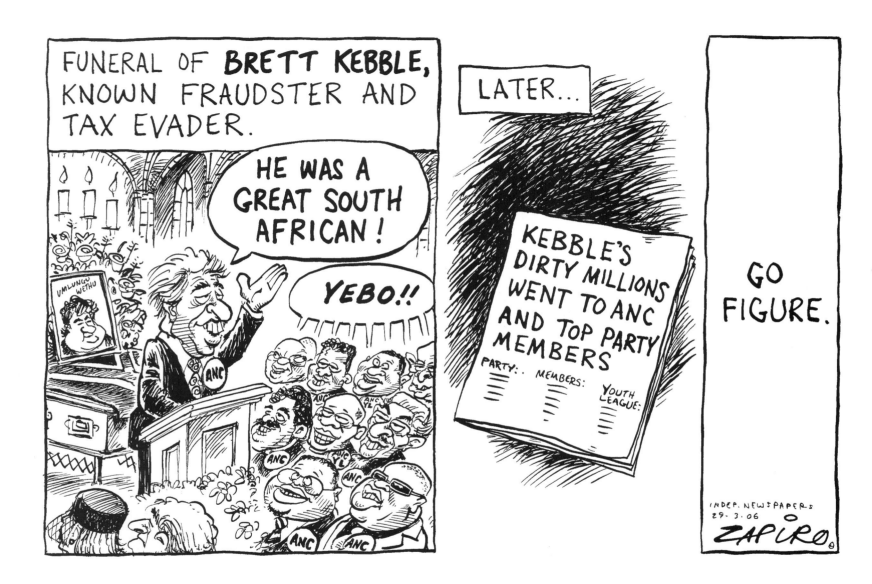

Half a year since his glorious send-off

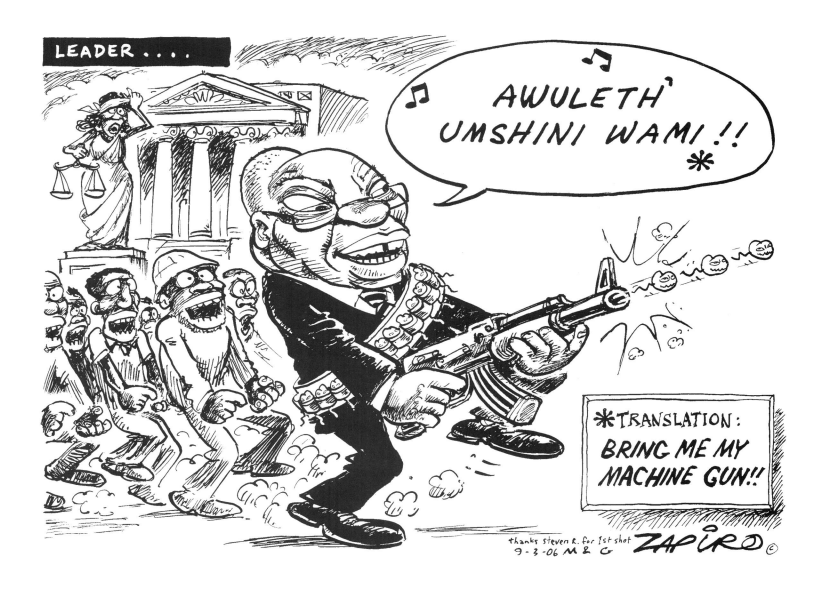

9 March 2006

Outside court, Zuma supporters burn pictures of his rape accuser, shouting 'Burn the bitch'. Zuma stirs it up with his trademark song.

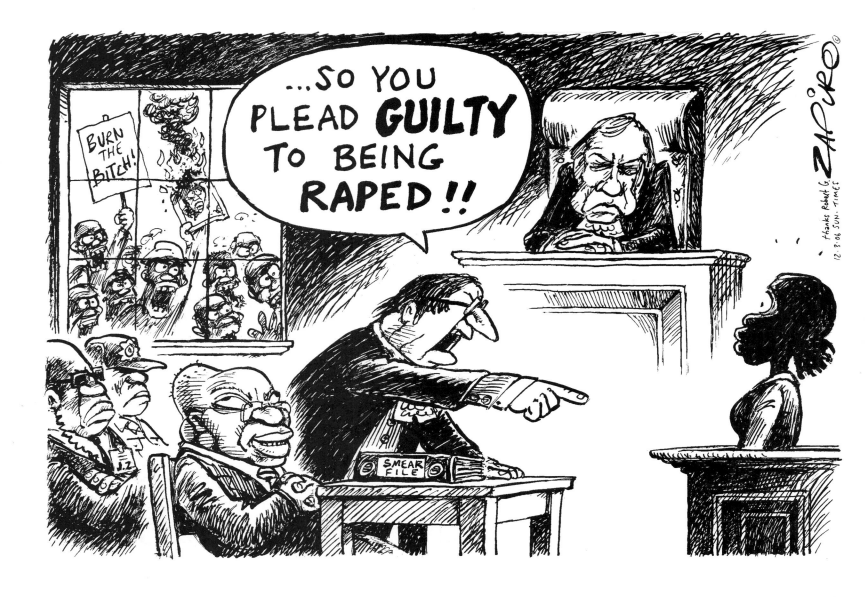

12 March 2006

Zuma's counsel, Kemp J. Kemp, drags the sexual history of Zuma's
HIV-positive accuser into the courtroom, grilling her on previous rapes

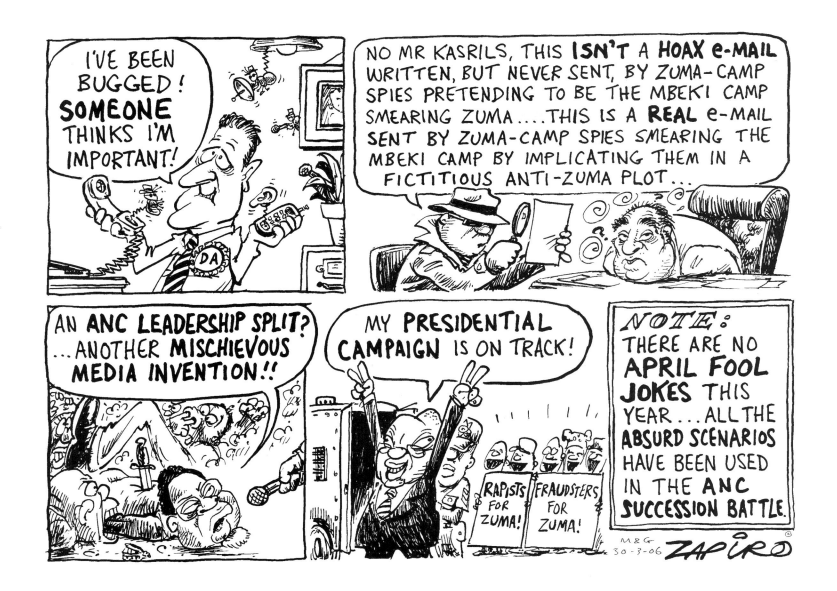

Bugging of politicians and a hoax e-mail campaign are found to be pro-Zuma
mischief by Intelligence director-general Billy Masetlha, who's then sacked

30 March 2006

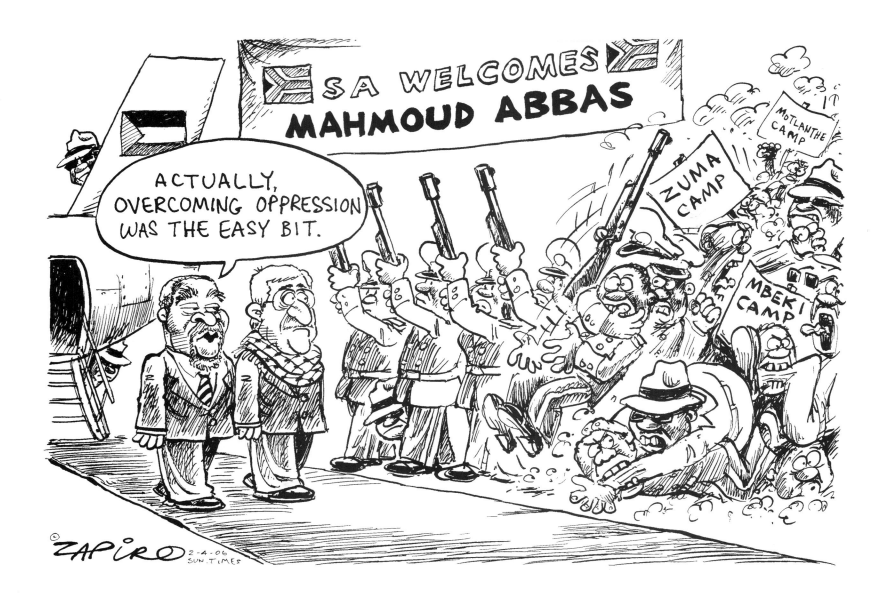

2 April 2006

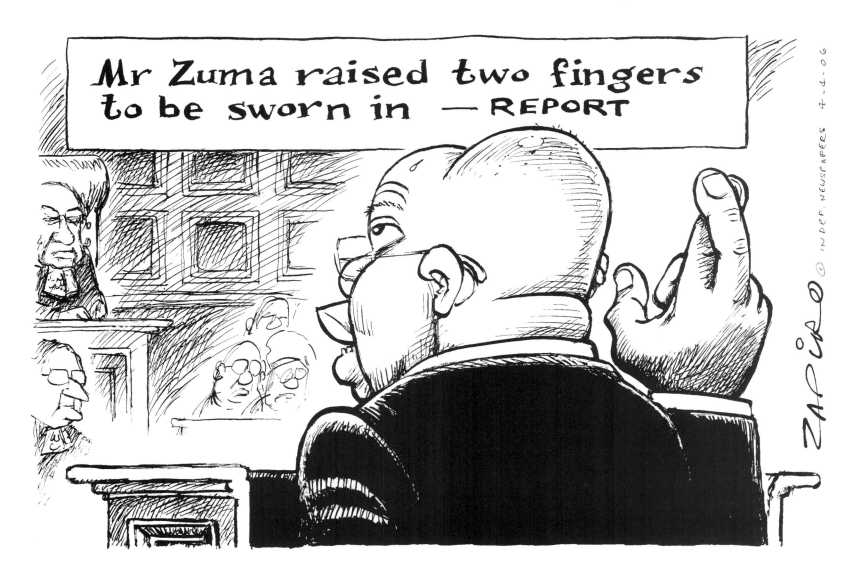

4 April 2006

At his rape trial, testifying in his own defence

79

GOING THRU HER PREDECESSOR'S DESK,
THE DEPUTY PRESIDENT FINDS....

THE **JACOB ZUMA MORAL DEGENERATION HANDBOOK**

A. ETHICS SECTION

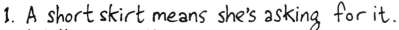

1. A short skirt means she's asking for it.
2. "No" means "Give it to me, big boy!"
3. When having casual sex, always apologize for not having a condom.
4. Before casual unprotected sex, remove brain and place on bedside table.
5. After casual unprotected sex, permanently remove conscience before then sleeping with your life partner(s).

B. LEADERSHIP SECTION

1. Being DEPUTY PRESIDENT means:
 — backhanders, bribes and babes
2. The MORAL REGENERATION MOVEMENT means:
 — using baby-oil for re-arousal.
3. What one needs to know about HIV/AIDS to be HEAD OF THE NATIONAL AIDS COUNCIL:
 — absolutely nothing.

thanks brent m.
5.4.06 / INDEP. NEWSPAPERS

ZAPIRO

5 April 2006

Was he at risk through unprotected sex with an HIV-positive woman? Not really, he says. His full testimony speaks volumes.

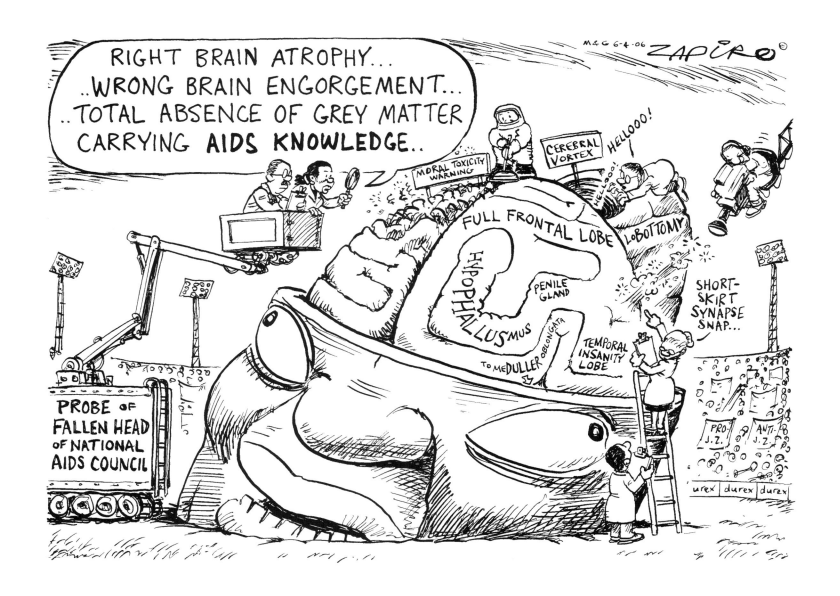

6 April 2006

And then, during televised cross-examination, he reveals
he had a shower after the sex to 'minimise the HIV risk'

Jacob Zuma's 101 USES FOR A CONDOM

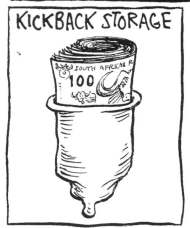

KICKBACK STORAGE

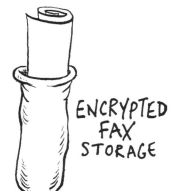

ENCRYPTED FAX STORAGE

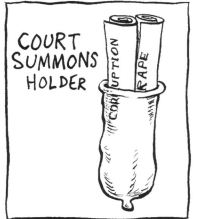

COURT SUMMONS HOLDER

KEEPING SPECTACLES USED TO SEE **SHORT SKIRTS** BETTER

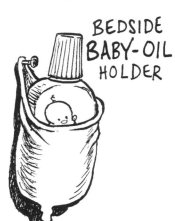

BEDSIDE **BABY-OIL** HOLDER

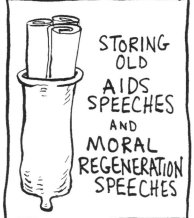

STORING OLD **AIDS** SPEECHES AND **MORAL REGENERATION** SPEECHES

TO KEEP YOUR **LOST MARBLES** (IF EVER FOUND)

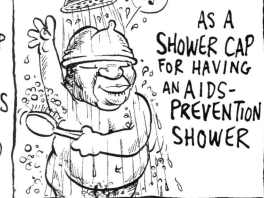

AS A **SHOWER CAP** FOR HAVING AN **AIDS-PREVENTION** SHOWER

ZAPIRO © SUN-TIMES 9-4-06

 ... AND WHEN TRYING NOT TO BE RECOGNIZED.

9 April 2006

82

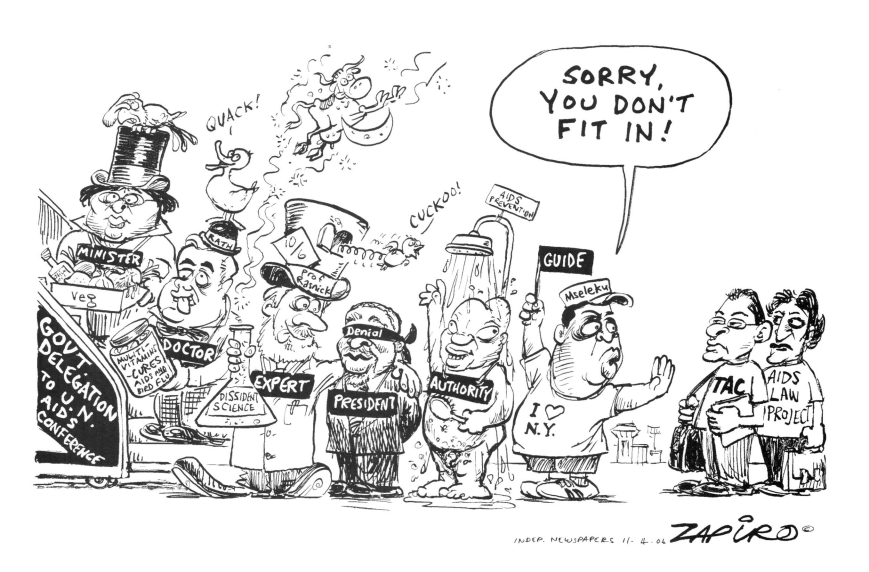

11 April 2006

Weeks ahead of the UN Special Session on Aids, government excludes the
Treatment Action Campaign and the Aids Law Project from the national delegation

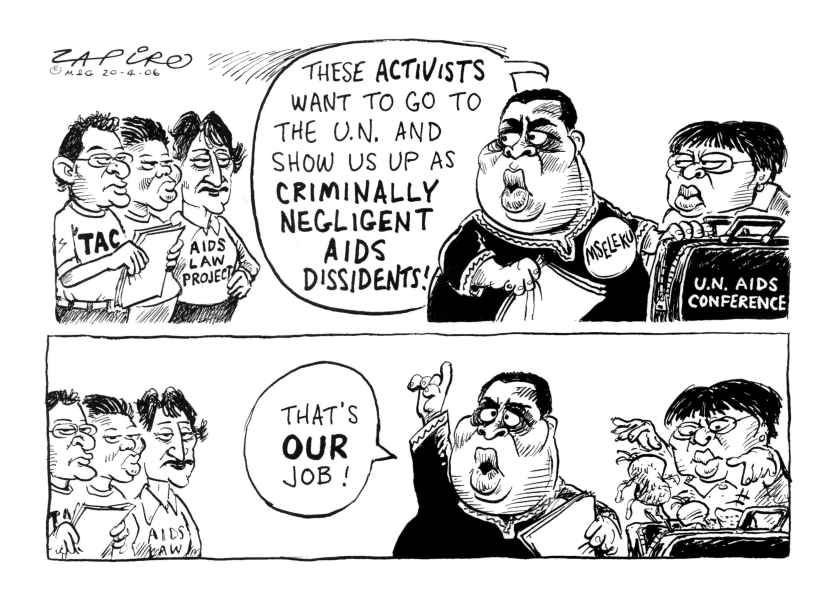

Government then sets conditions for their participation, which
they reject. They'll eventually go to the UN under their own steam.

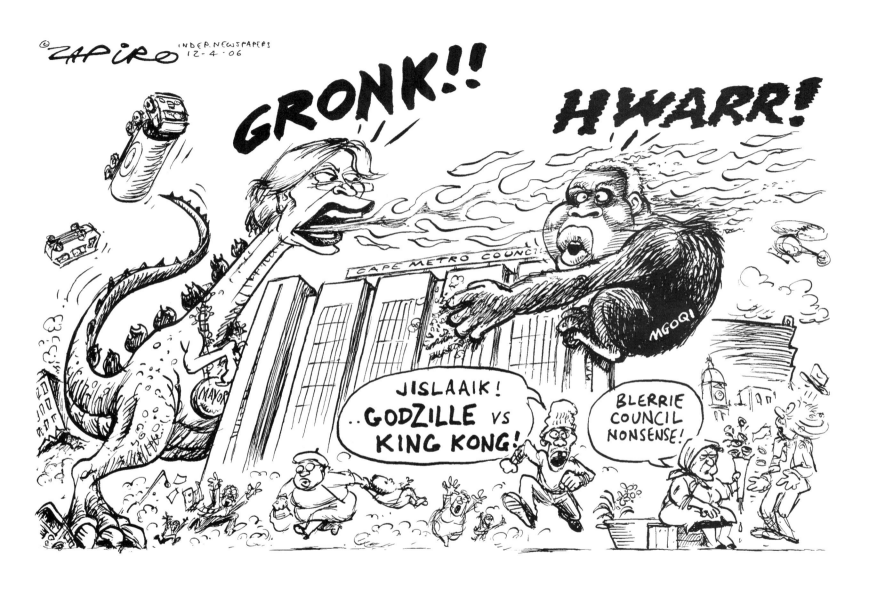

Cape farce: Wallace Mgoqi's contract as city manager, extended by the previous mayor,
is revoked and he's replaced but he defies his axing and keeps on coming to work

12 April 2006

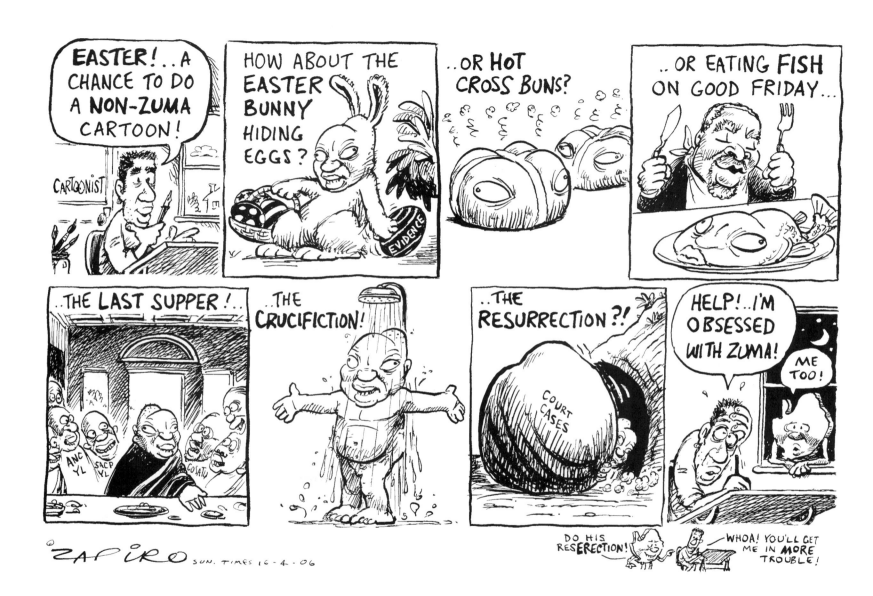

16 April 2006

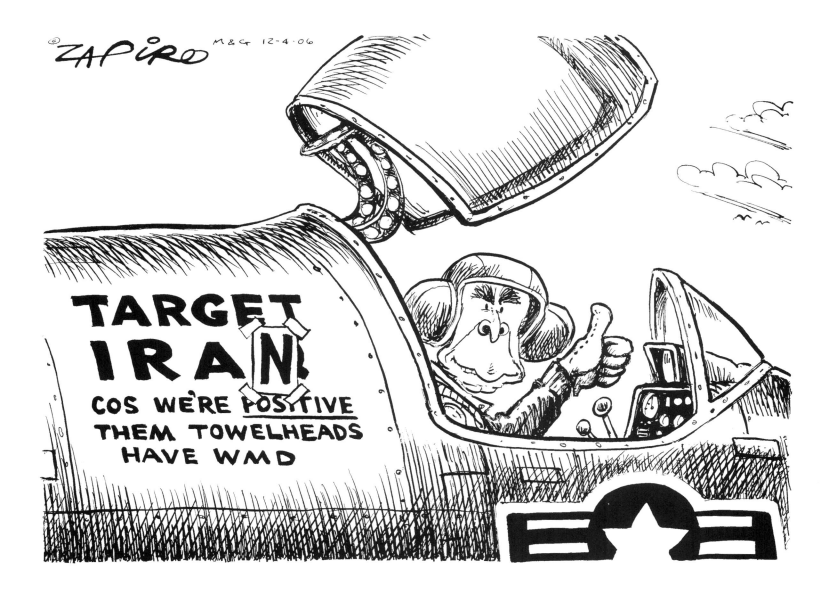

Believing Iran is trying to build an atomic bomb, the US steps up plans for an air strike

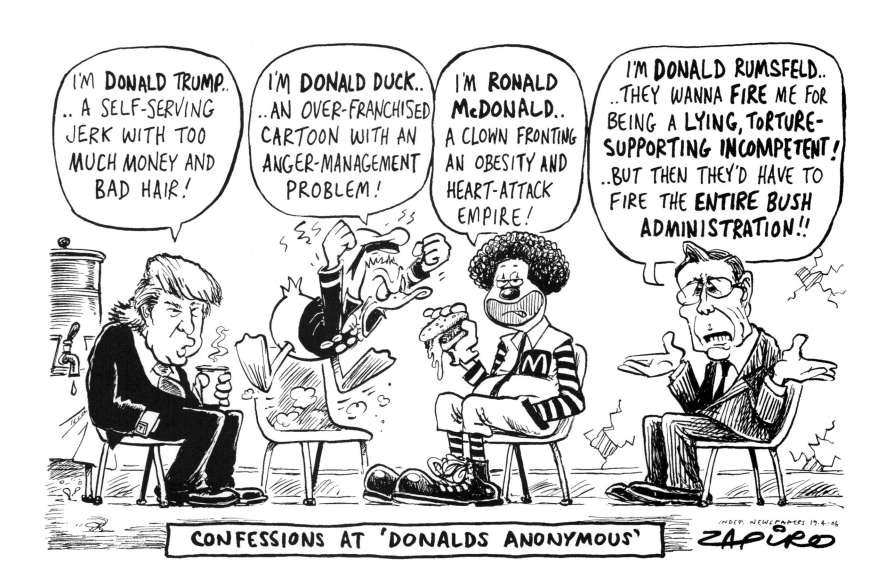

Six former US generals call for Defense Secretary Rumsfeld's removal

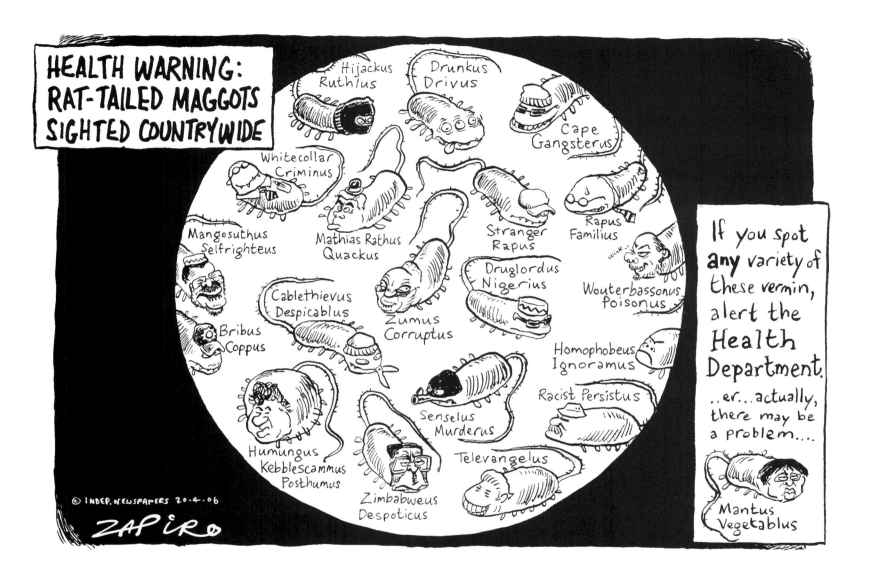

In a water supply near you

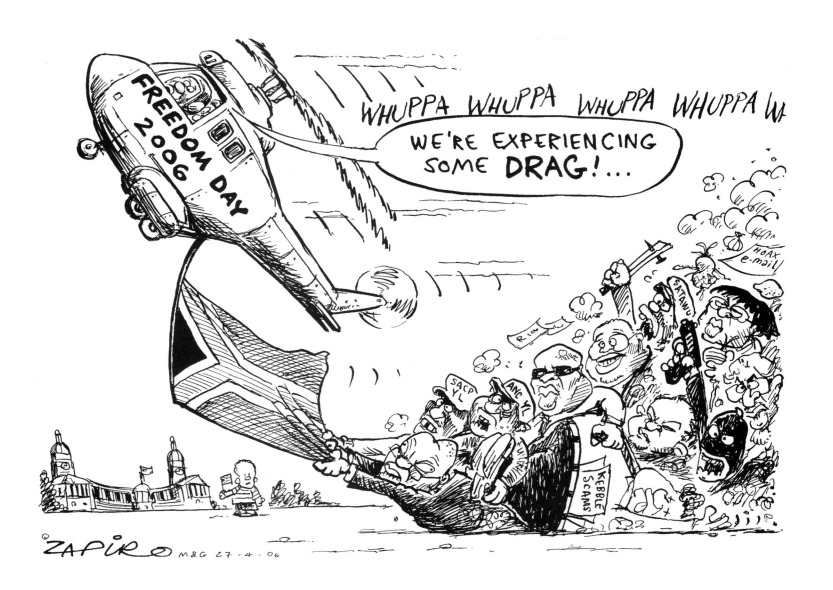

27 April 2006

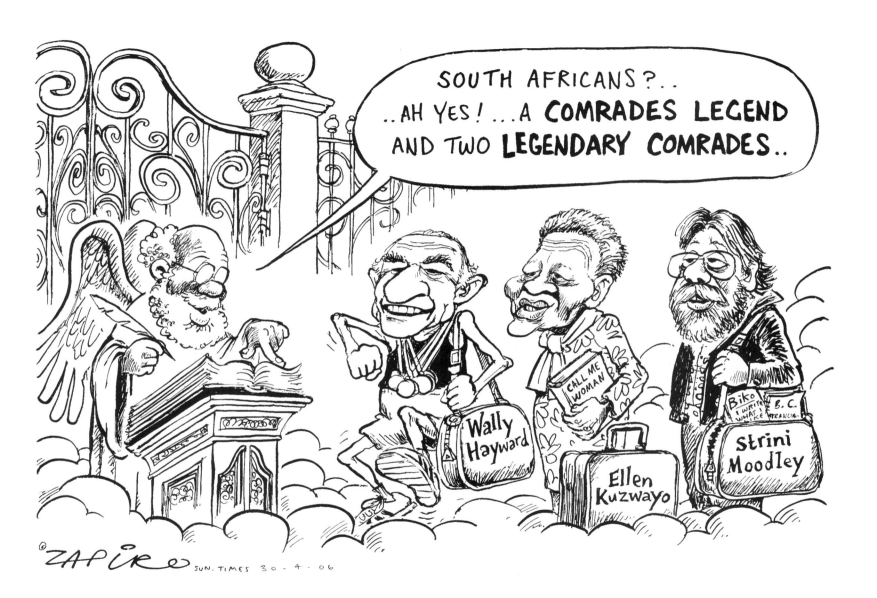

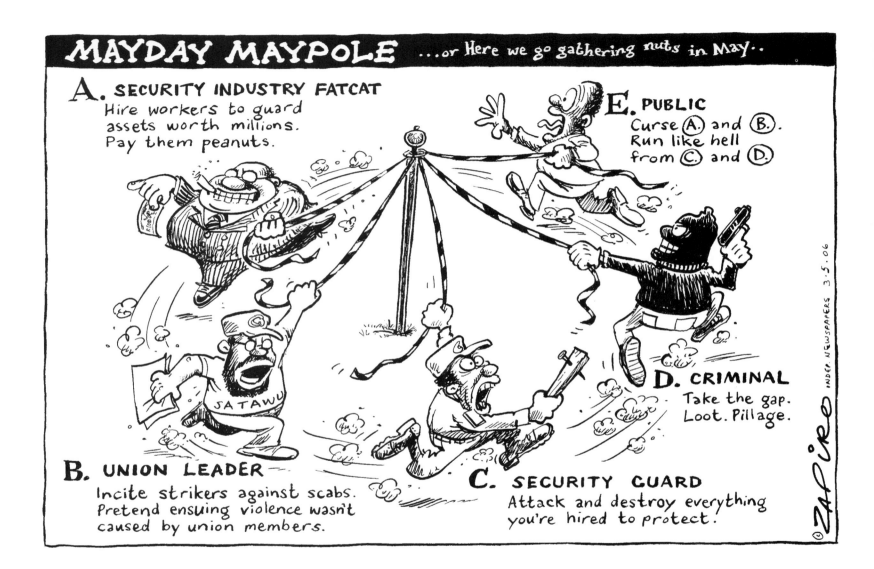

Cosatu abandons its Cape Town May Day rally and calls in police as hundreds of its own
striking security guard members violently disrupt proceedings and rampage through the city

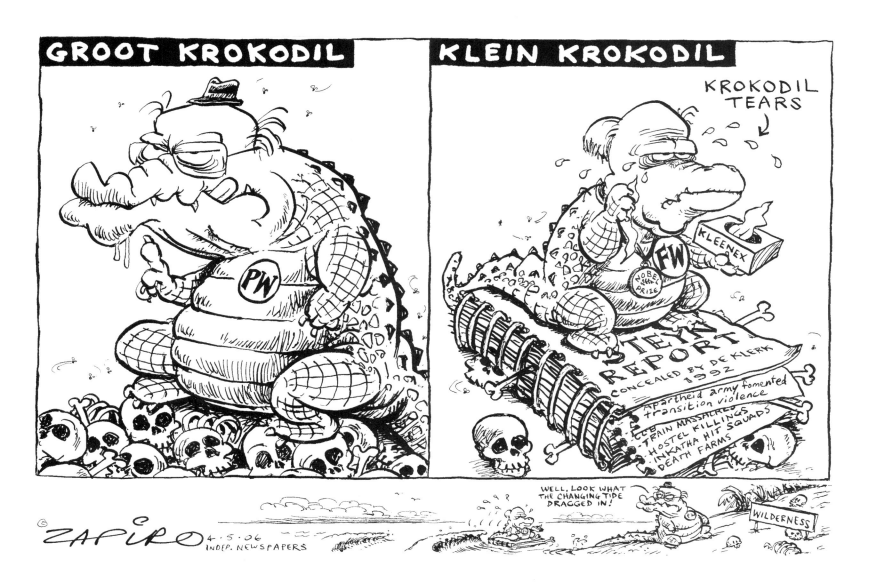

4 May 2006

The now-declassified Steyn report reveals how the SA Defence Force
fuelled violence in the dying days of National Party rule

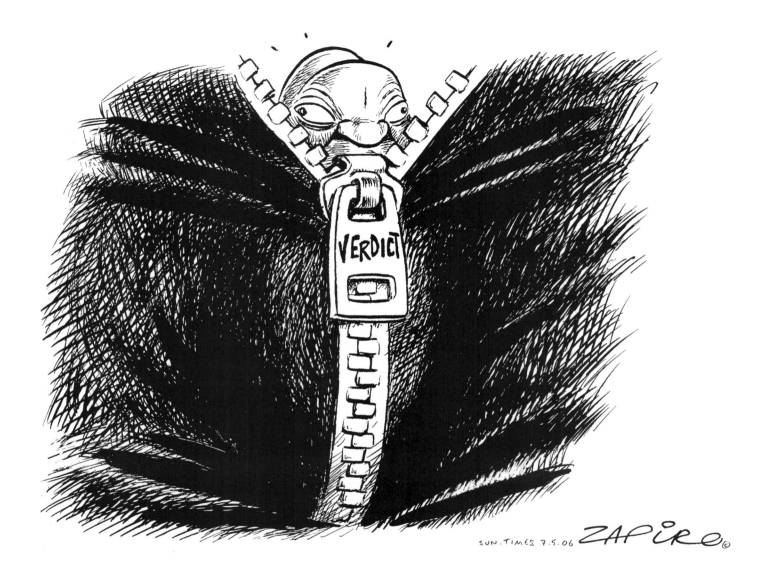

7 May 2006

Televised rape trial judgment tomorrow

94

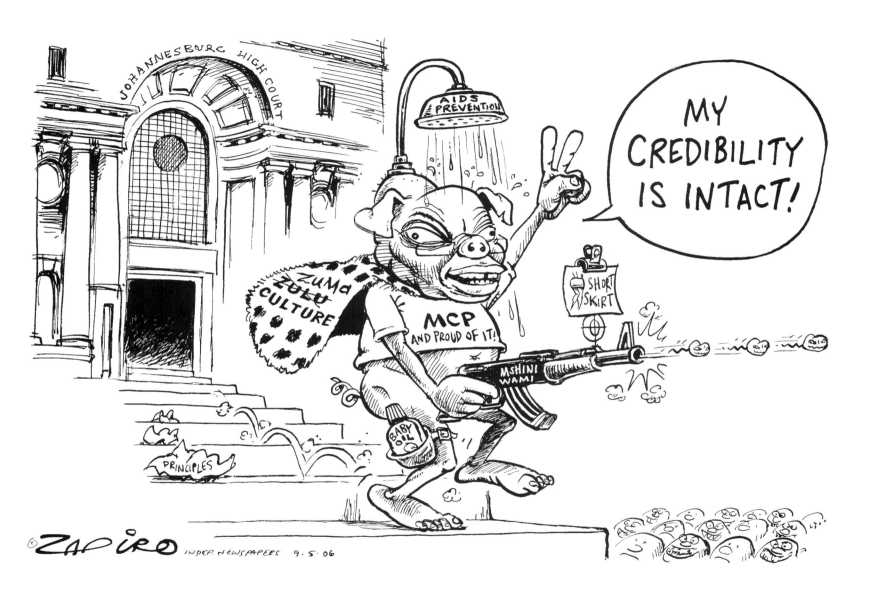

9 May 2006 Acquitted. But chastised by the judge for being unable to control his sexual urges.

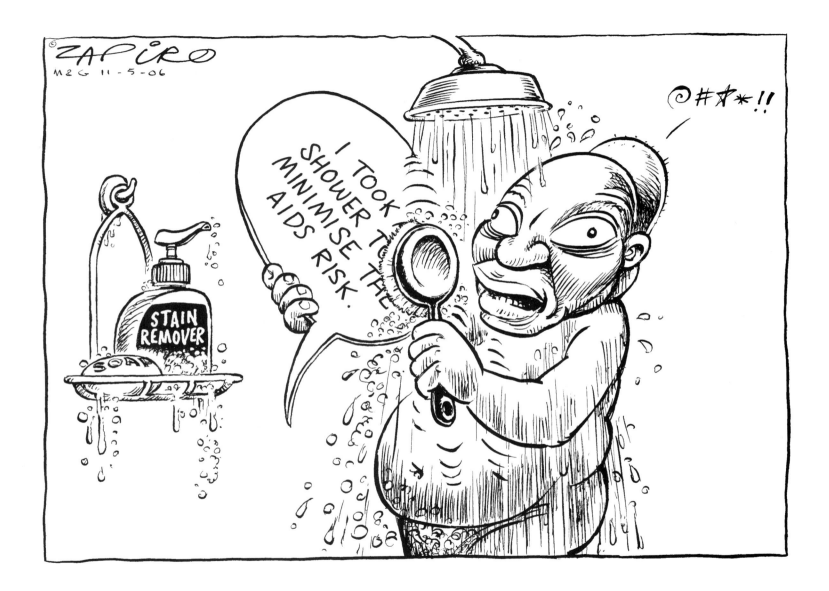

11 May 2006

At a press conference, he denies he said a shower could prevent HIV

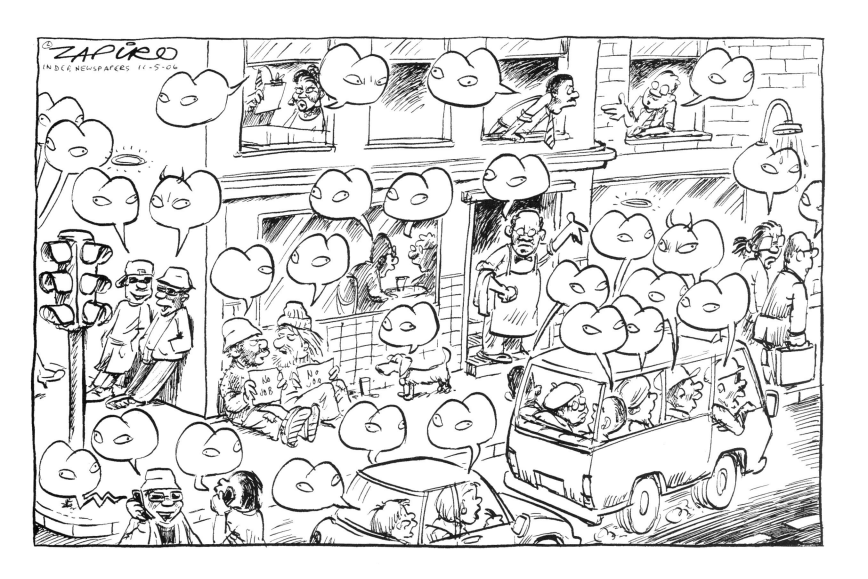

11 May 2006

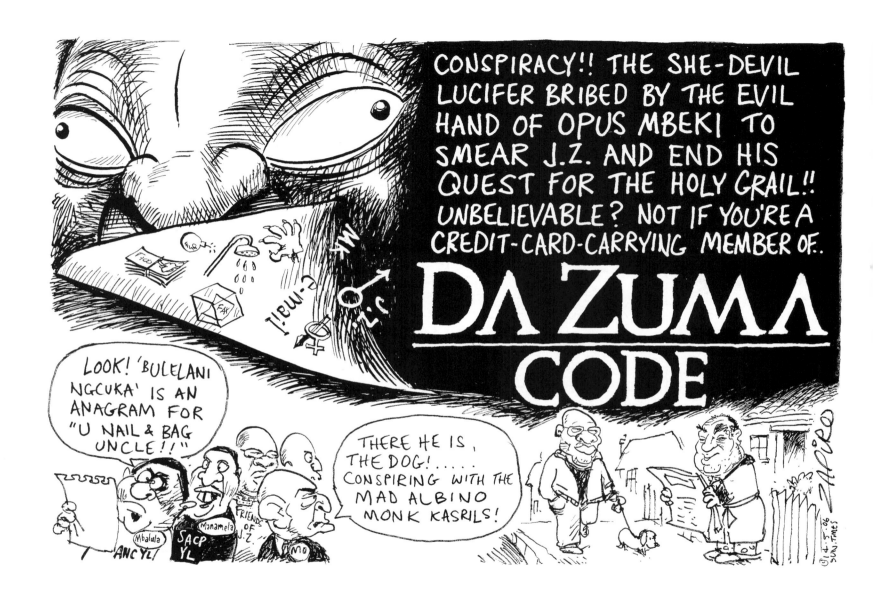

14 May 2006

The ANC Youth League's conspiracy theory: Zuma's rape trial accuser ('Lucifer') was bribed to lay charges, helped by the 'evil hand' of Bulelani Ngcuka and Intelligence Minister Ronnie Kasrils

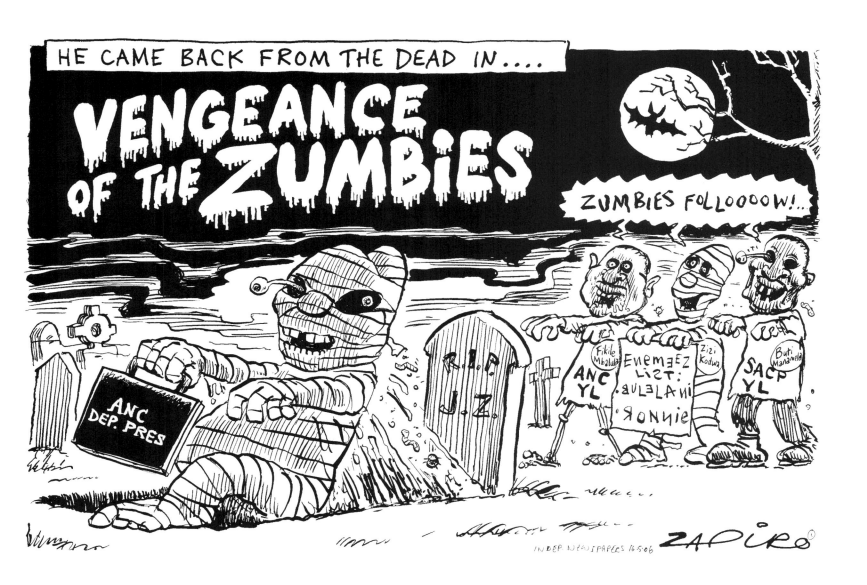

16 May 2006

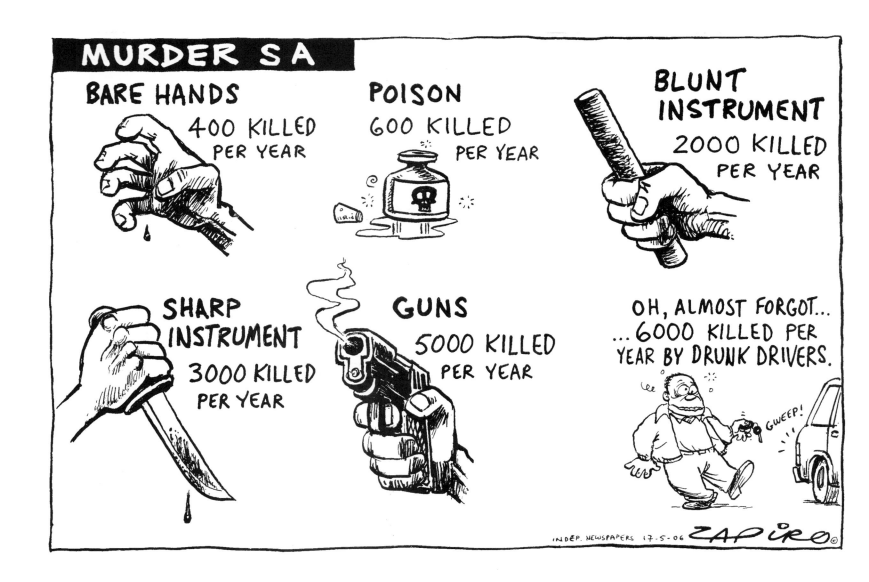

17 May 2006

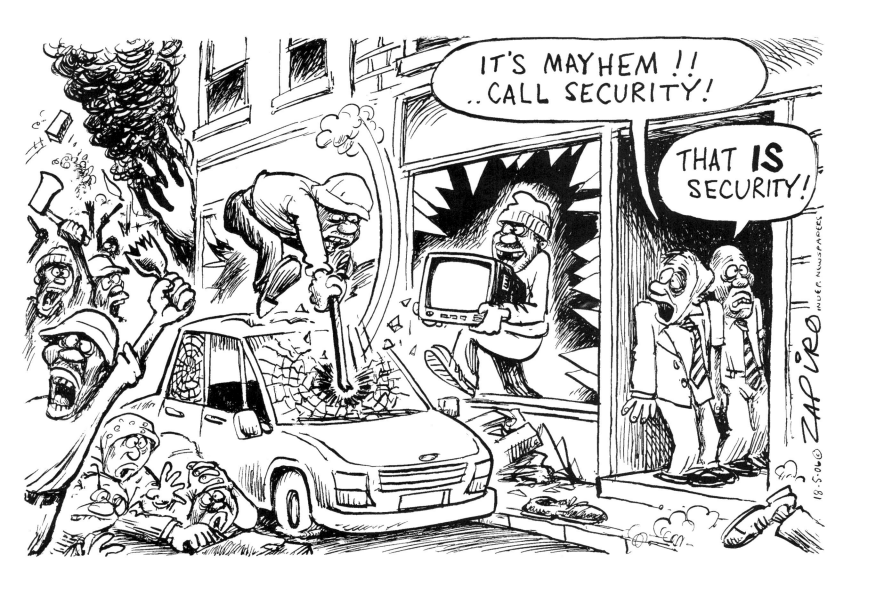

18 May 2006 Cape Town's city centre again vandalised by striking security guards

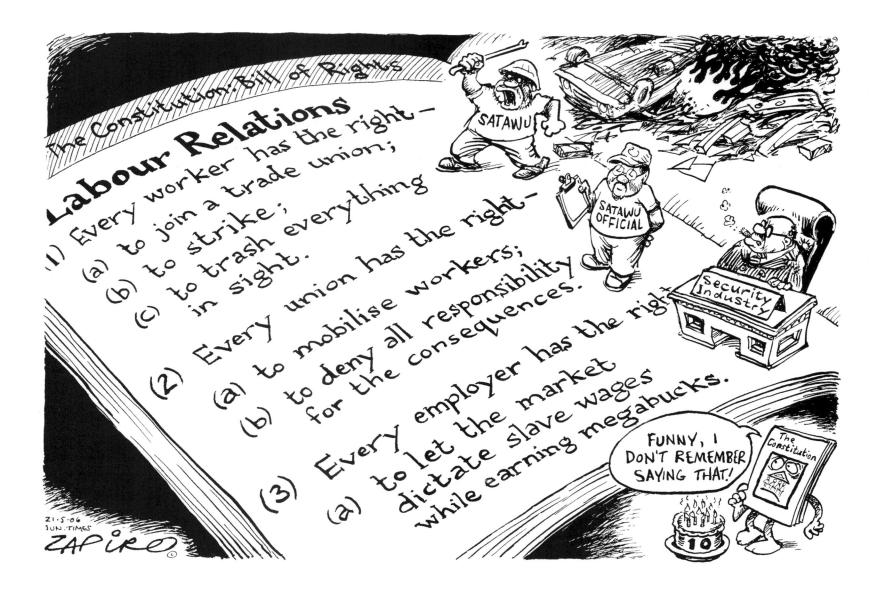

21 May 2006

The SA Transport and Allied Workers' Union strike turns violent countrywide.
People are thrown off moving trains. Trains and buses are torched.

GERMANY 2006: SOUTH AFRICAN VISITORS HAVE BEEN WARNED OF **RACISM** IN CERTAIN AREAS.

IN RETURN WE PROVIDE THE GERMAN TOURIST WITH THE..

SA 2010 GETTING-TO-THE-STADIUM HANDBOOK

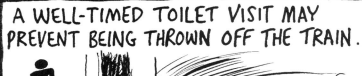

WHEN IN A TAXI, ALWAYS KEEP YOUR HEAD DOWN.

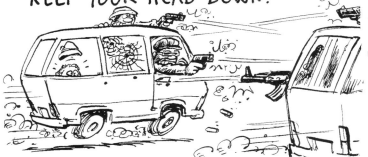

A WELL-TIMED TOILET VISIT MAY PREVENT BEING THROWN OFF THE TRAIN.

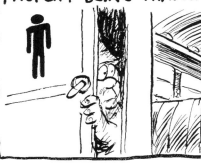
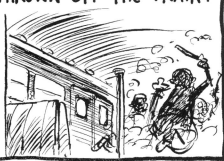

TRY TO EXIT THE BUS **BEFORE** IT IS TORCHED.

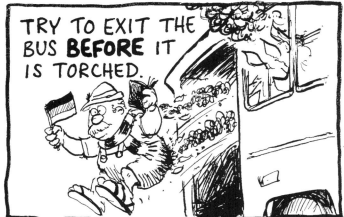

PROBLEMS EN ROUTE? DO **NOT** CALL SECURITY.

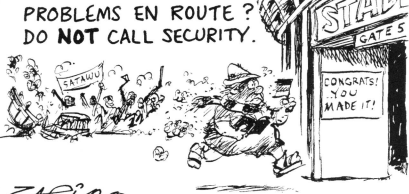

CONGRATS! YOU MADE IT!

ZAPIRO © M&G 18.5.06

18 May 2006

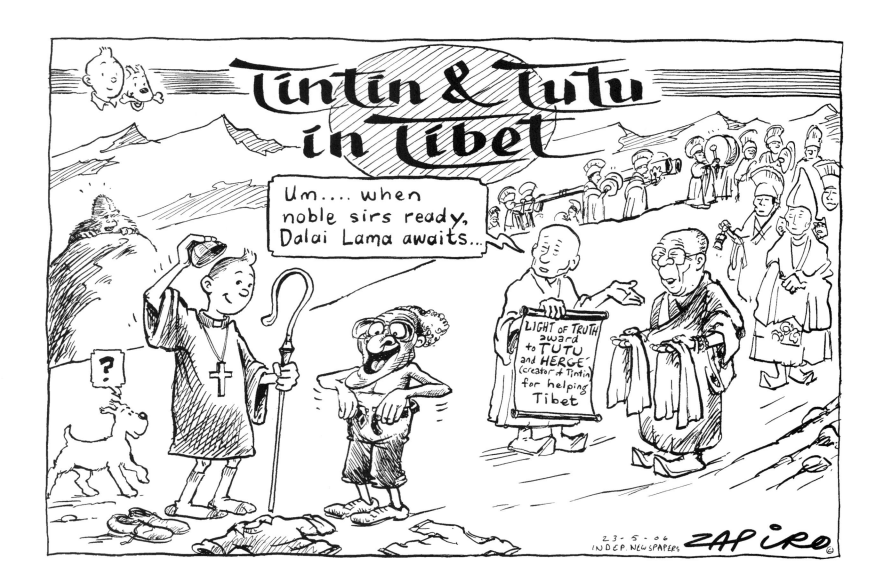

23 May 2006

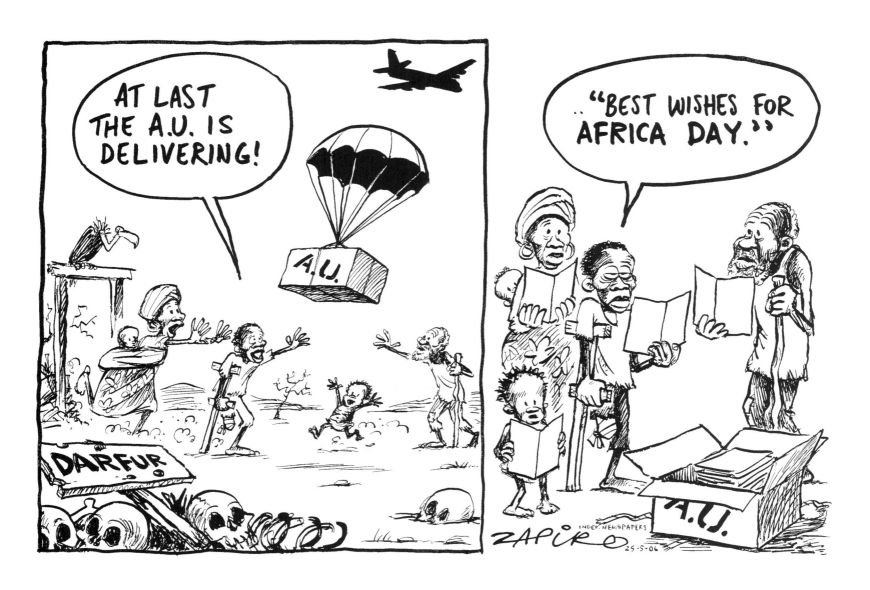

25 May 2006

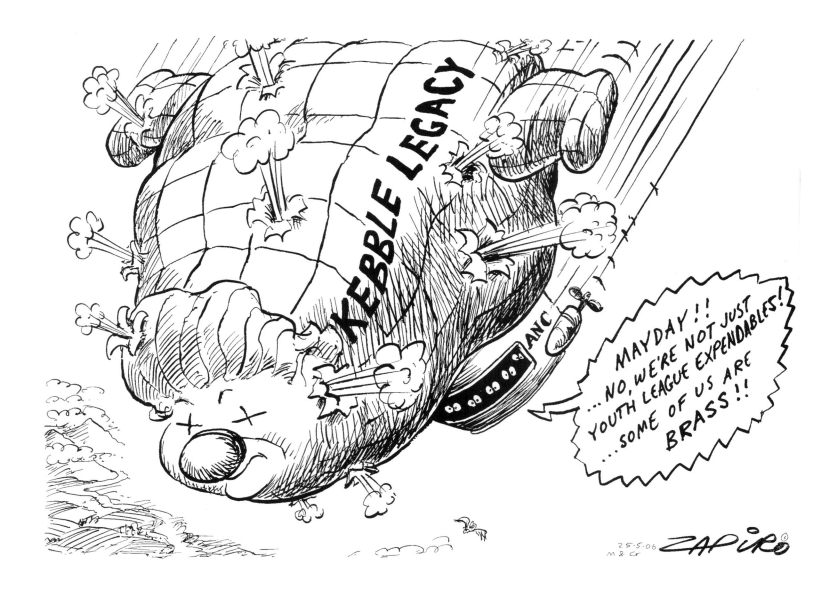

The ANC and leading party members received
R95 million of stolen shareholders' money from Brett Kebble

25 May 2006

NUM's edited TEN COMMANDMENTS

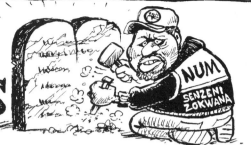

Thou shalt have no other gods before Jacob Zuma.

Thou shalt not take the name of Zuma in vain, even when he talks bull about showers.

Thou shalt not make any graven image or earthly likeness, especially those goggle-eyed bump-headed J.Z. cartoons.

Thou shalt not kill *His* chance for a shot at the Top Job.

Thou shalt not commit adultery with a potential honey-trap.

Thou shalt not steal, except for legitimate strike looting.

Thou shalt not bear false witness against thy neighbour, unless thy neighbour is Kasrils or Ngcuka.

Thou shalt not covet thy neighbour's house, nor his ass, but his wife's ass is fair game.

SUN.TIMES 28-5-06 ZAPIRO

28 May 2006

At the National Union of Mineworkers' conference, its president says Christians shouldn't judge Zuma's sexual antics. He also says the Ten Commandments mean nothing to NUM.

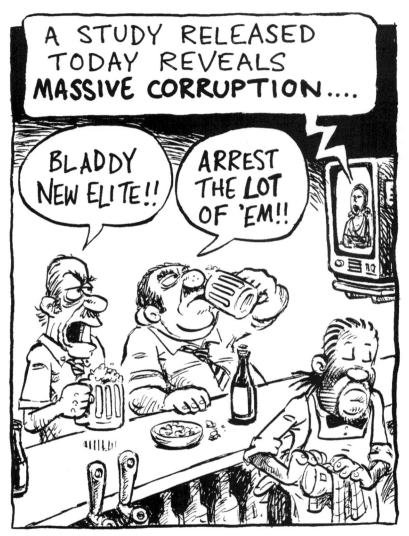

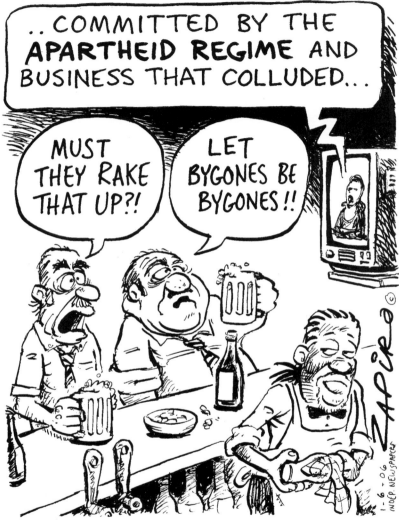

1 June 2006

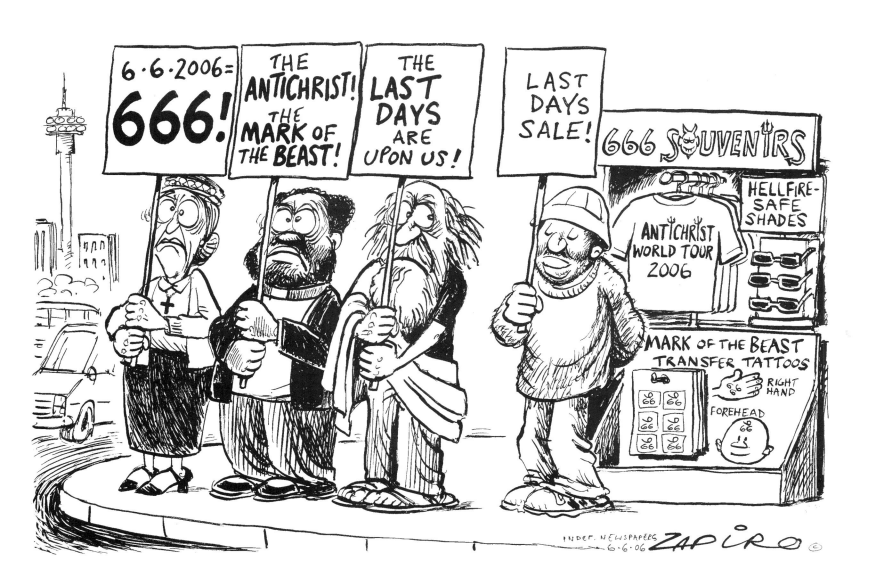

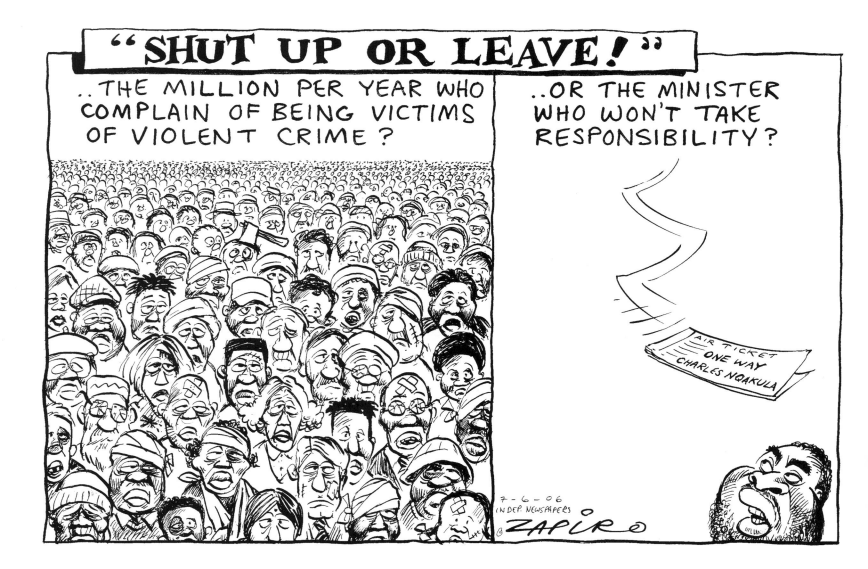

7 June 2006 The Safety and Security Minister says those who whinge about crime can leave the country

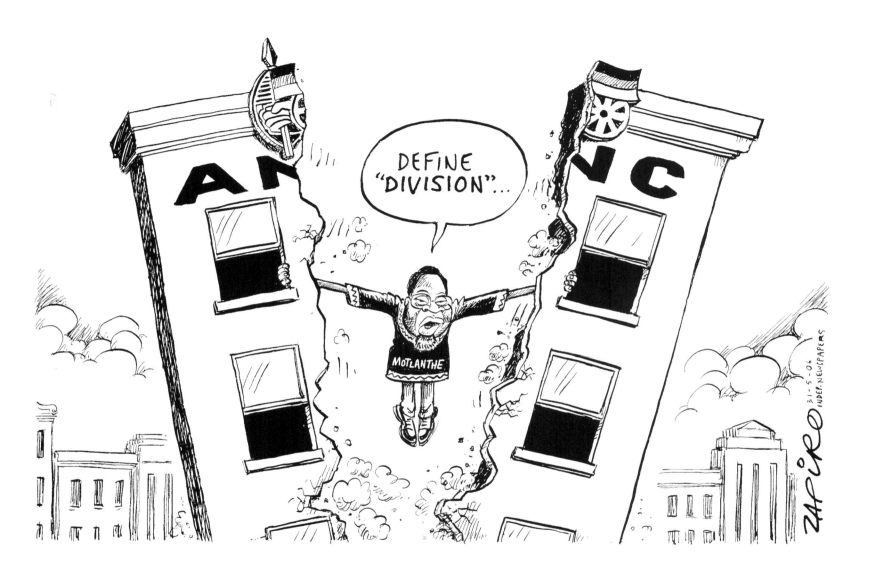

31 May 2006

While calling for an end to the succession debate,
ANC bigwigs again deny the party's divided

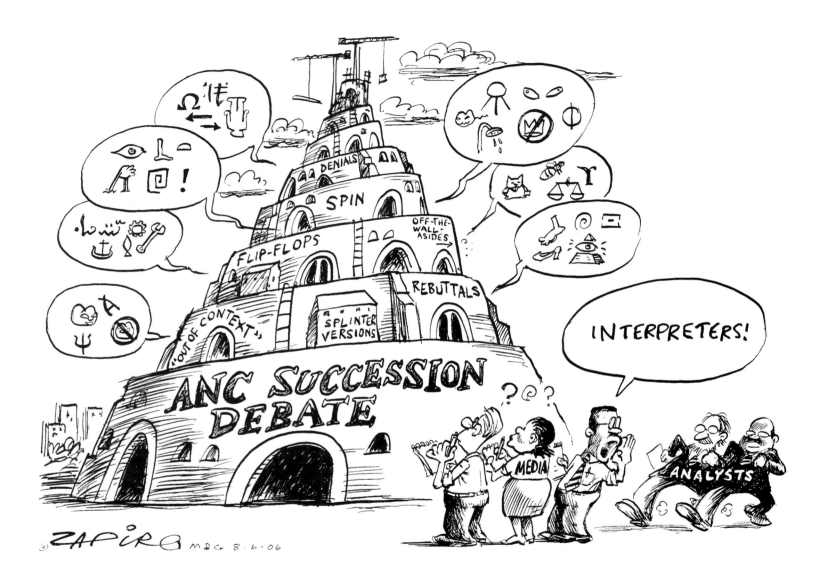

8 June 2006

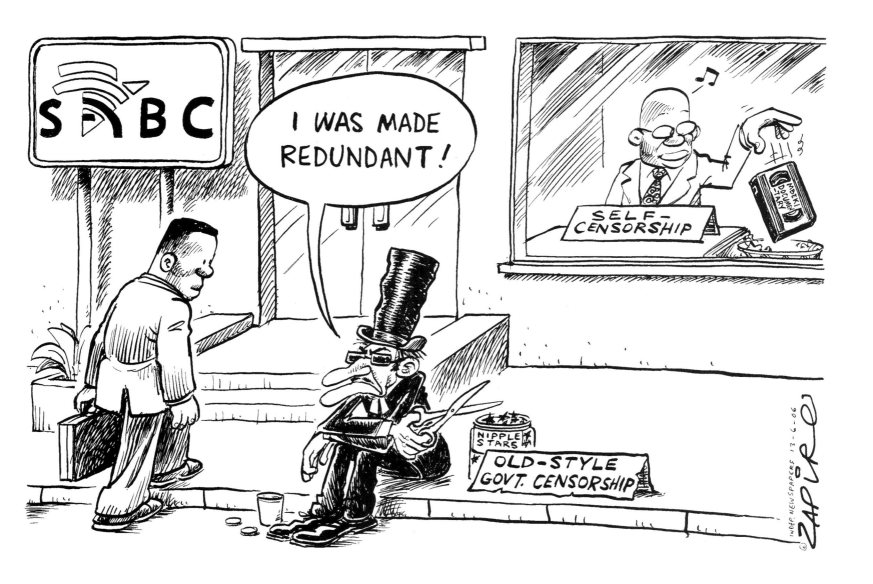

The SABC pulls the *Thabo Mbeki Unauthorised*
documentary and then gags its producers

11 June 2006

Kick-off of Germany 2006, the biggest World Cup ever

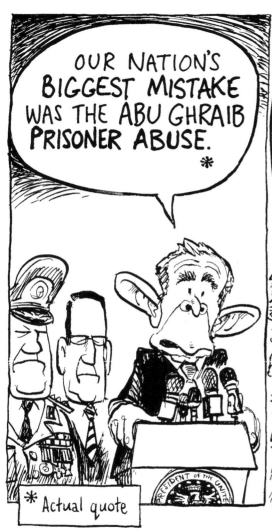

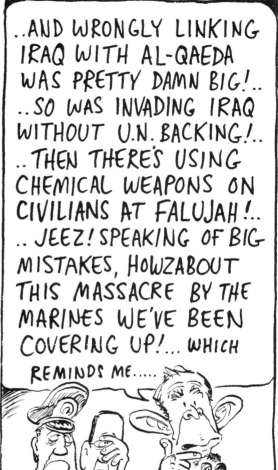

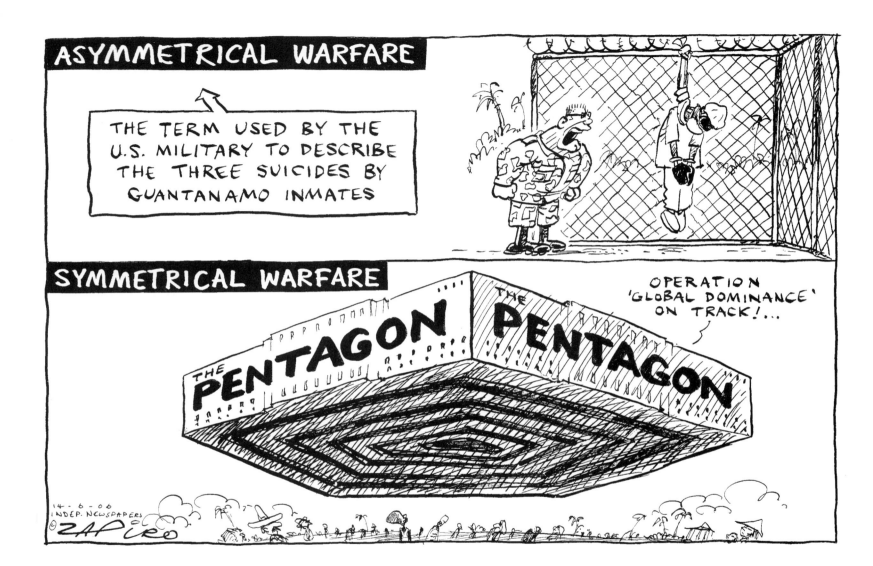

14 June 2006

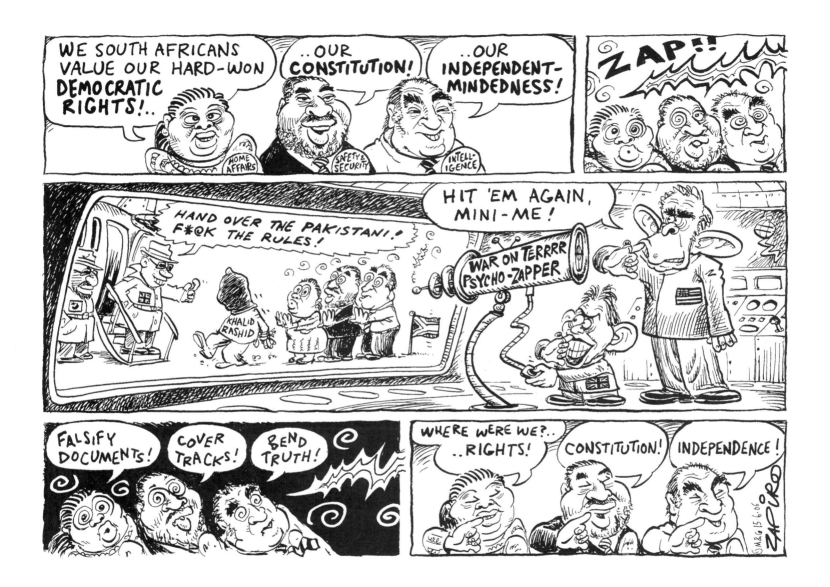

The deportation of Pakistani national Khalid Rashid turns out to be a covert rendition to Britain and Pakistan, a kowtowing by SA to the US-UK 'War on Terror'

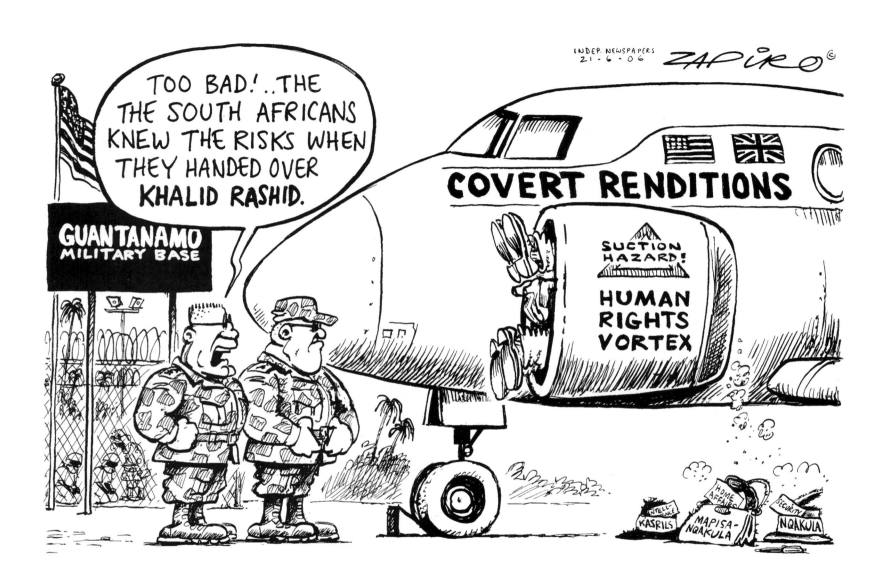

21 June 2006

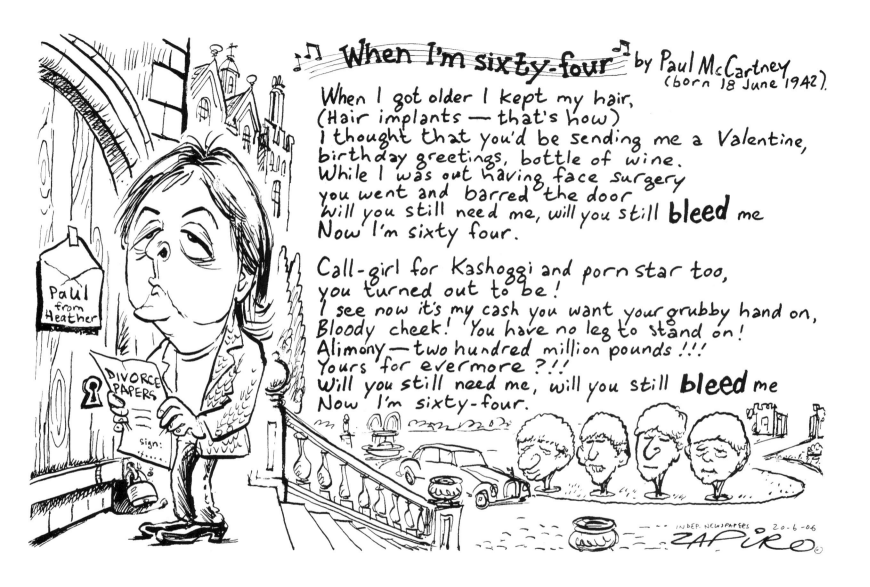

20 June 2006

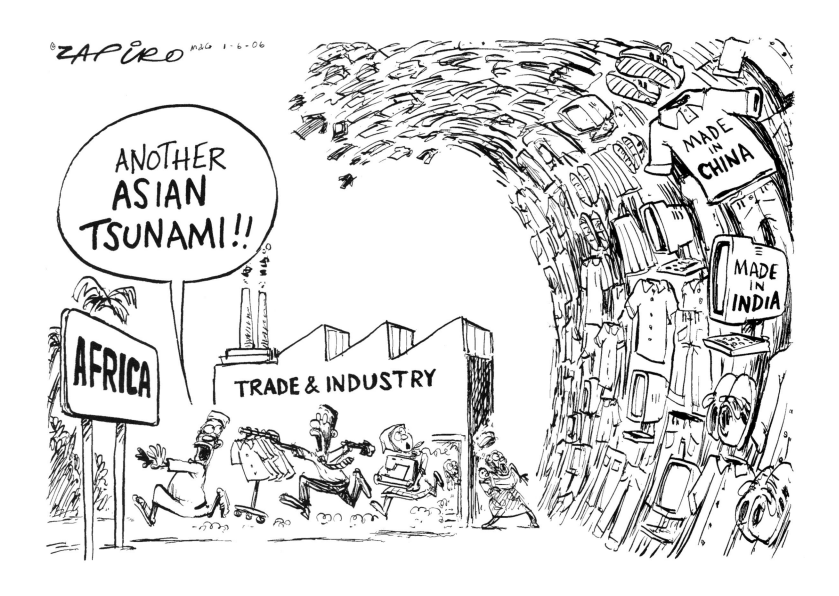

1 June 2006

Cheap goods become a threat

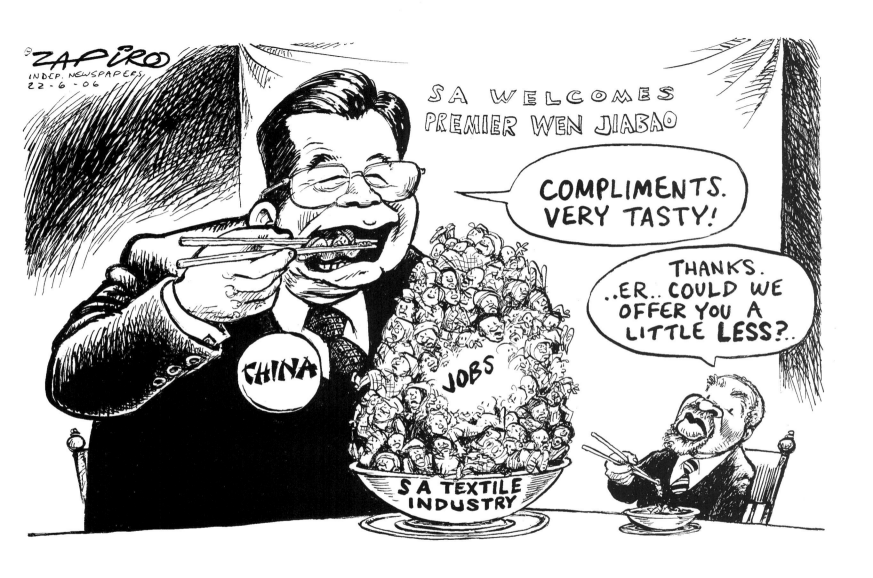

22 June 2006 25 000 jobs lost in two years. Mbeki wants China to restrict textile exports to SA.

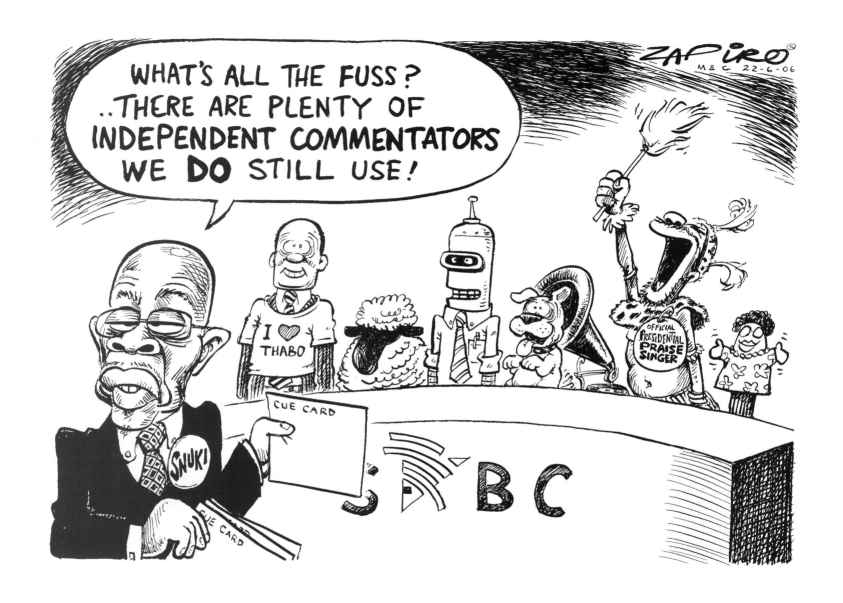

22 June 2006

SABC's *AM-Live* anchor John Perlman blows the whistle on head of news
Snuki Zikalala for imposing a blacklist on news analysts whose opinions he doesn't like

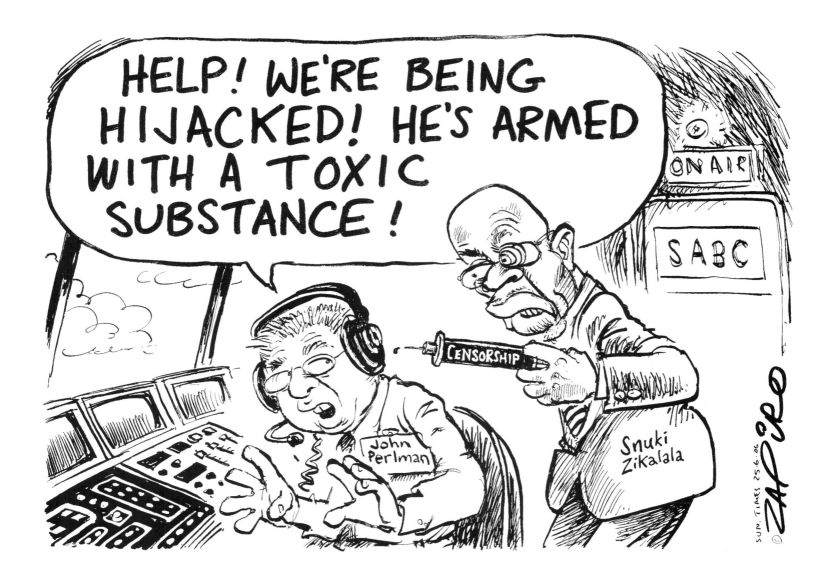

25 June 2006 … as a syringe-wielding student tries to hijack an SAA flight

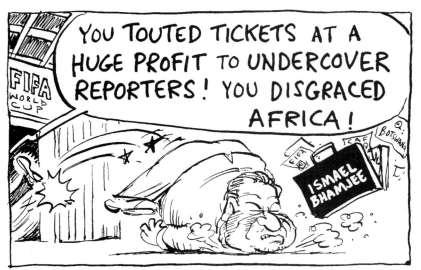

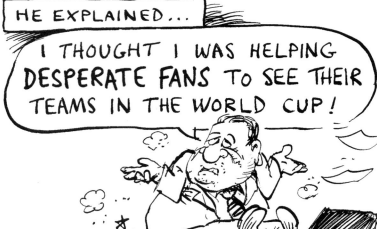

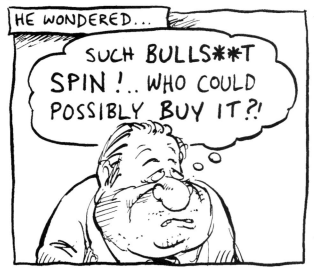

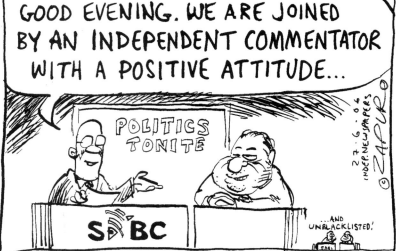

27 June 2006 The Botswana-based soccer honcho and FIFA exec member is sent home

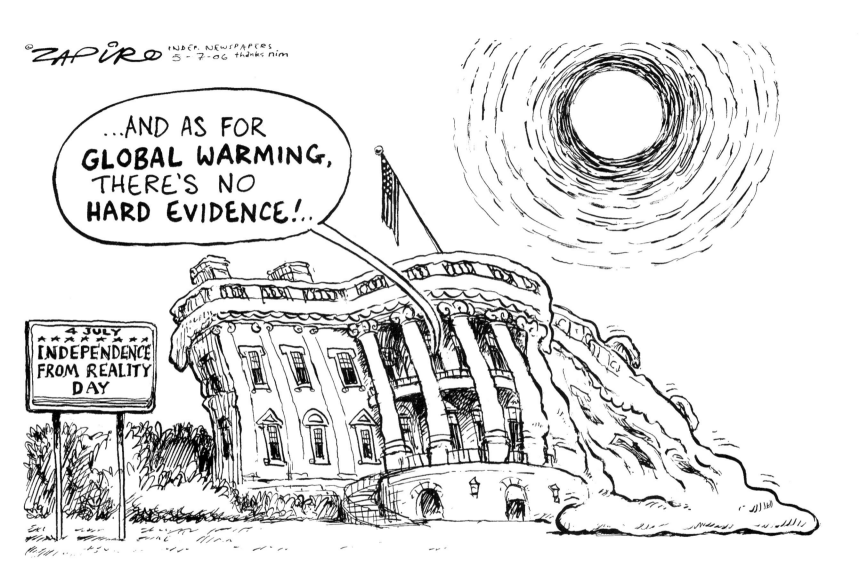

5 July 2006

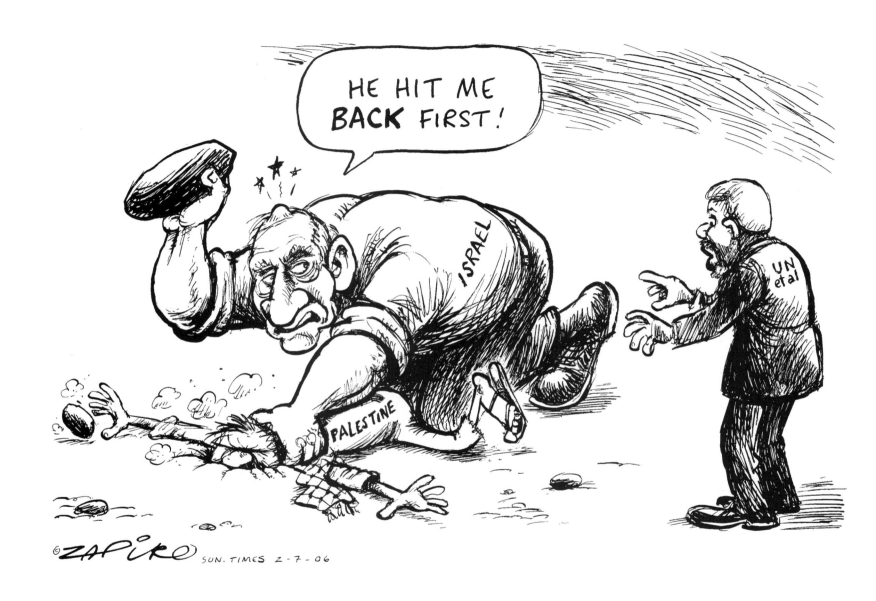

2 July 2006

After an Israeli corporal is abducted by Palestinian militants, Israel launches
an offensive in Gaza, arresting eight Palestinian cabinet ministers

126

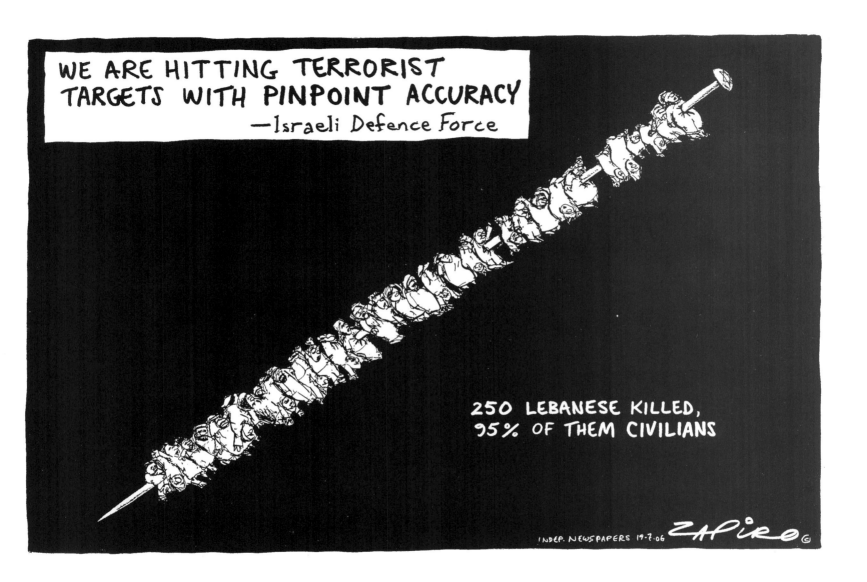

WE ARE HITTING TERRORIST TARGETS WITH PINPOINT ACCURACY
—Israeli Defence Force

250 LEBANESE KILLED, 95% OF THEM CIVILIANS

INDEP. NEWSPAPERS 19·7·06 ZAPIRO ©

Hezbollah guerrillas abduct two Israeli soldiers into Lebanon.
Israel retaliates with massive air strikes on Lebanon, devastating Beirut.

19 July 2006

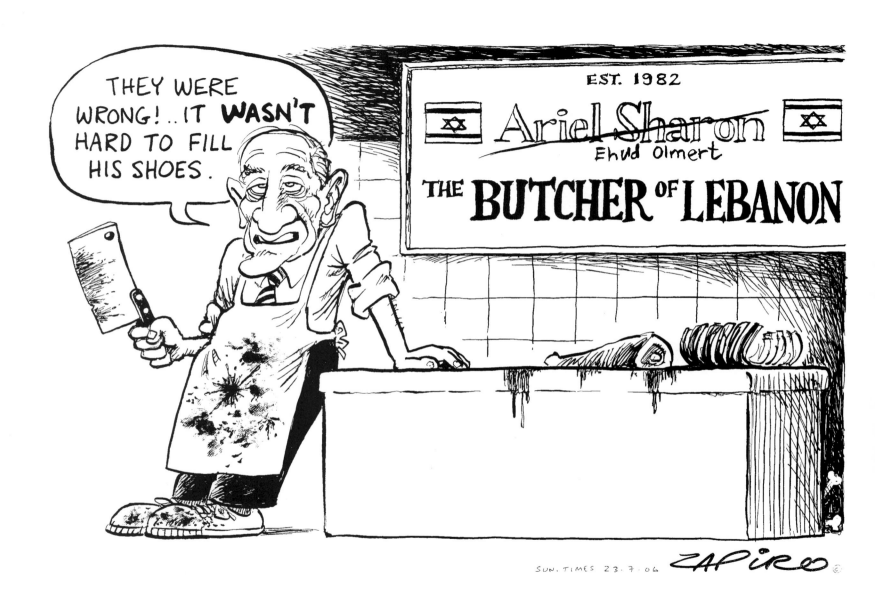

23 July 2006

As the Lebanese death toll approaches one thousand

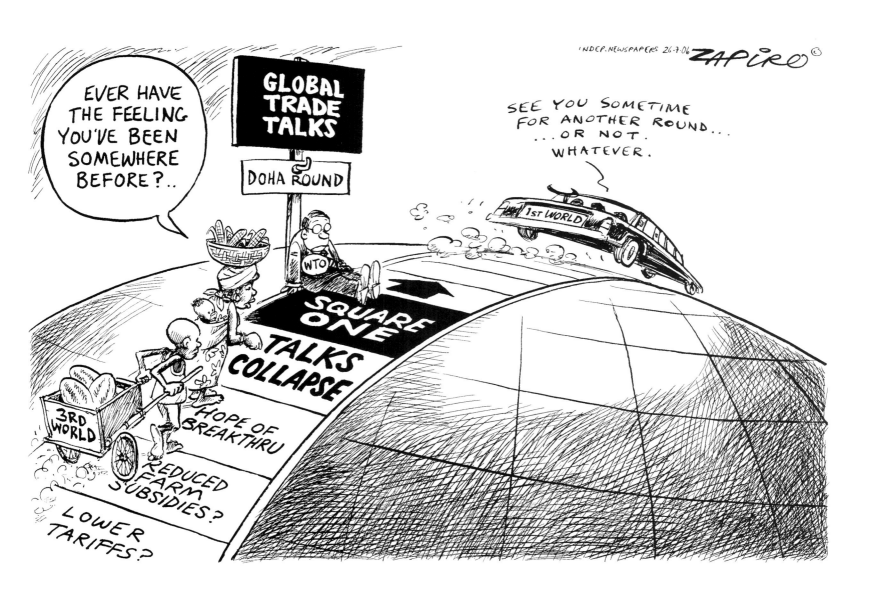

26 July 2006

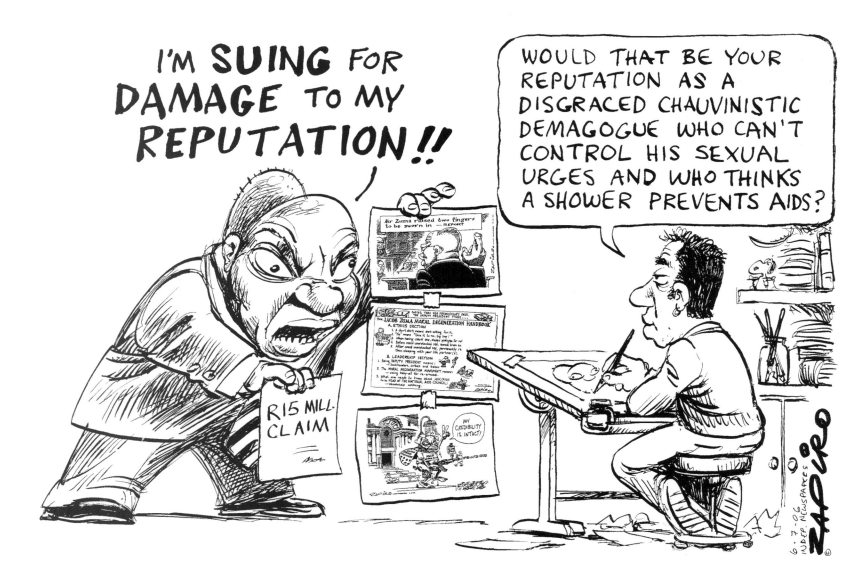

6 July 2006

Zuma sues the media for R63 million, targeting commentators, a radio show,
and a cartoonist (me – the biggest individual claim) who, he says, defamed him

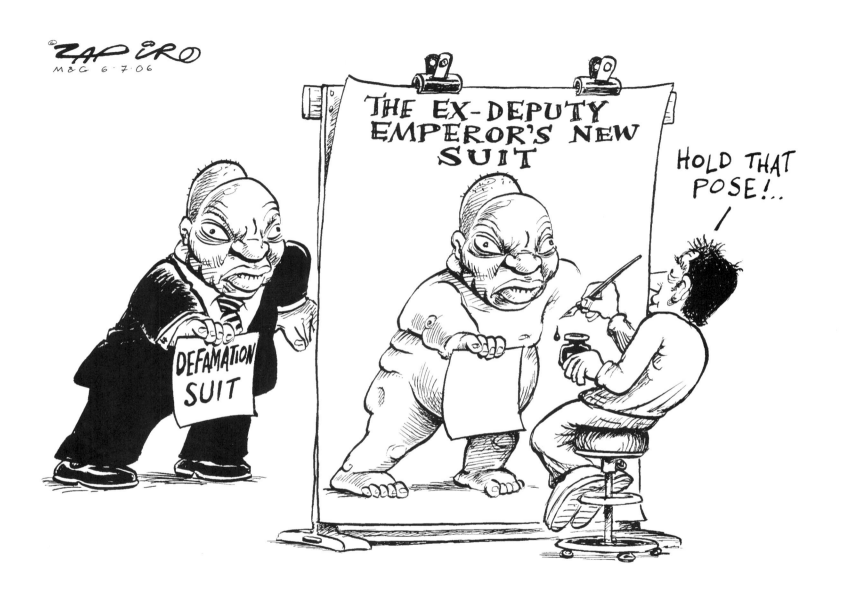

6 July 2006

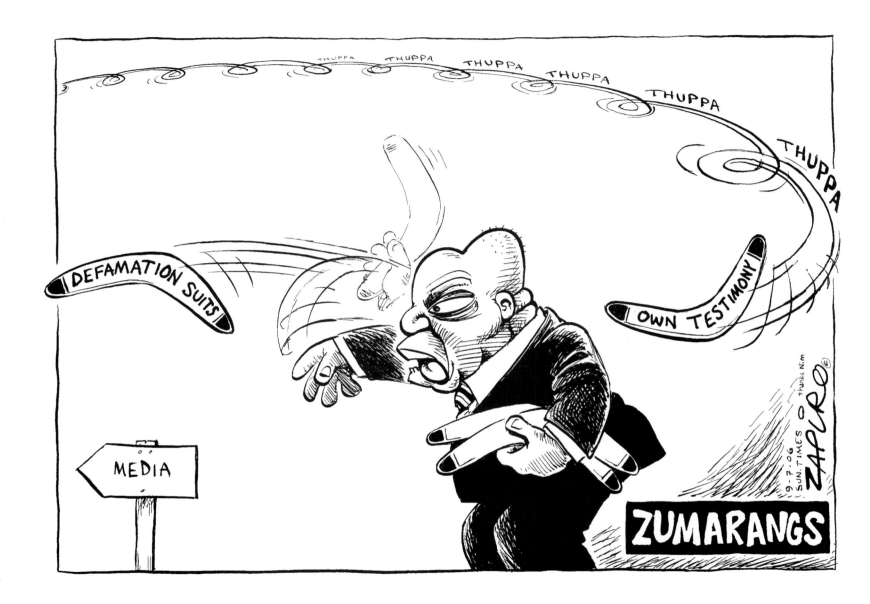

9 July 2006

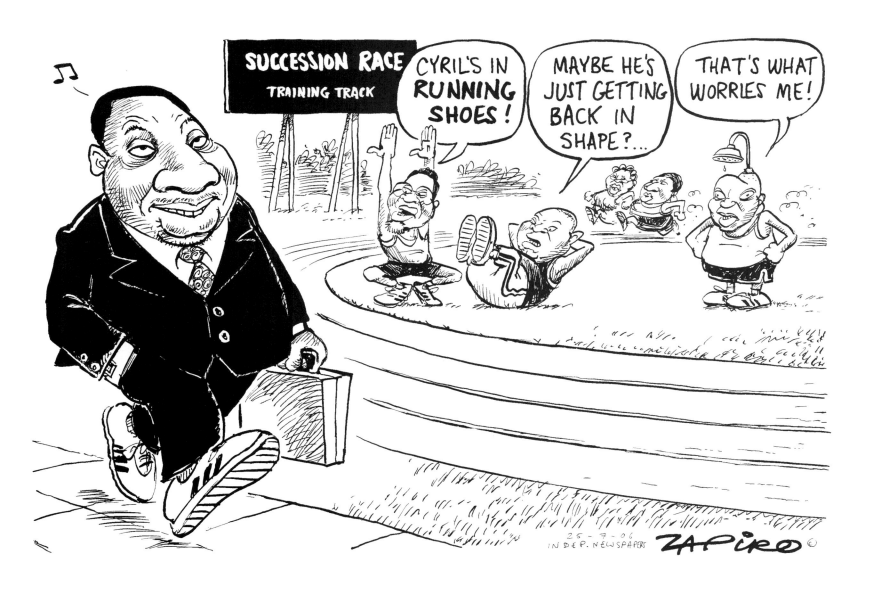

He's acting coy, but tycoon and ANC stalwart Cyril Ramaphosa
positions himself as an alternative to the obvious contenders

25 July 2006

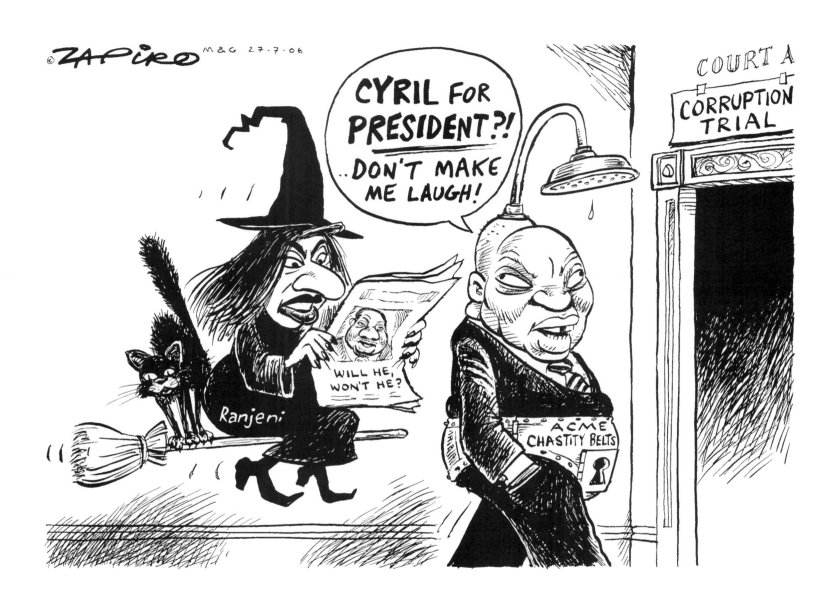

27 July 2006

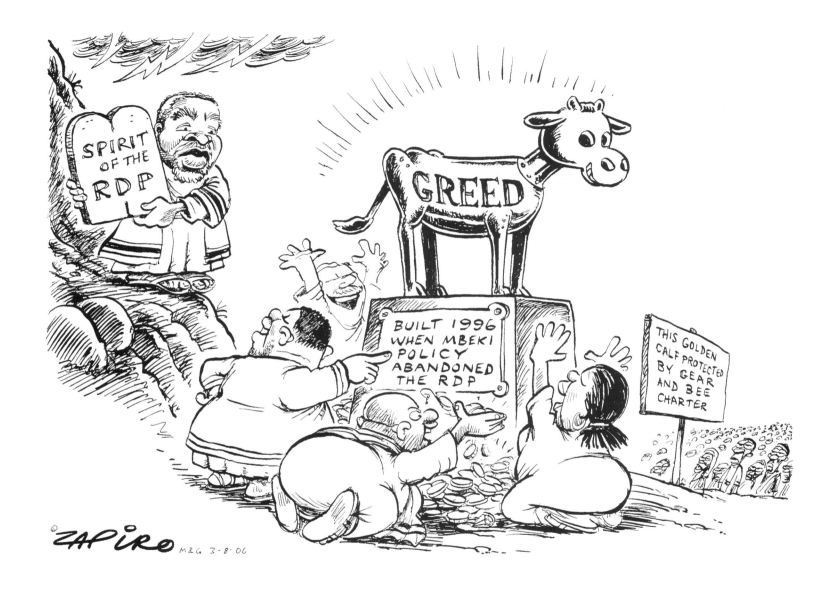

3 August 2006 President Mbeki lambastes the prevailing worship of wealth

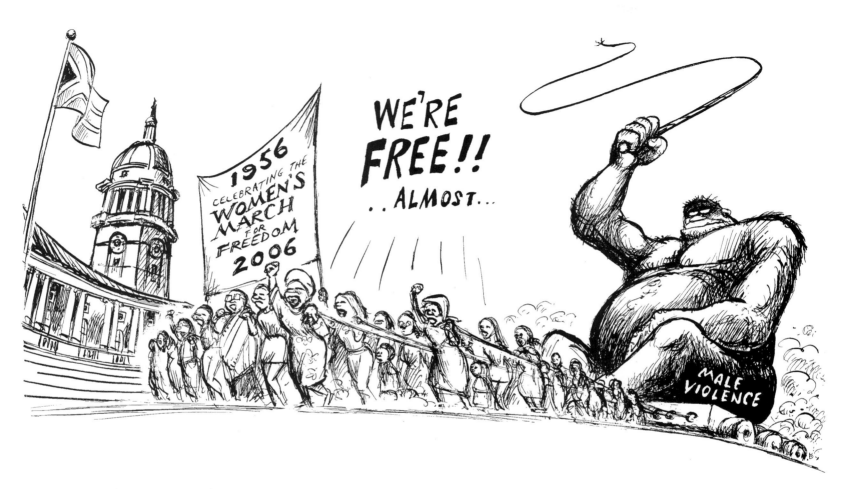

9 August 2006

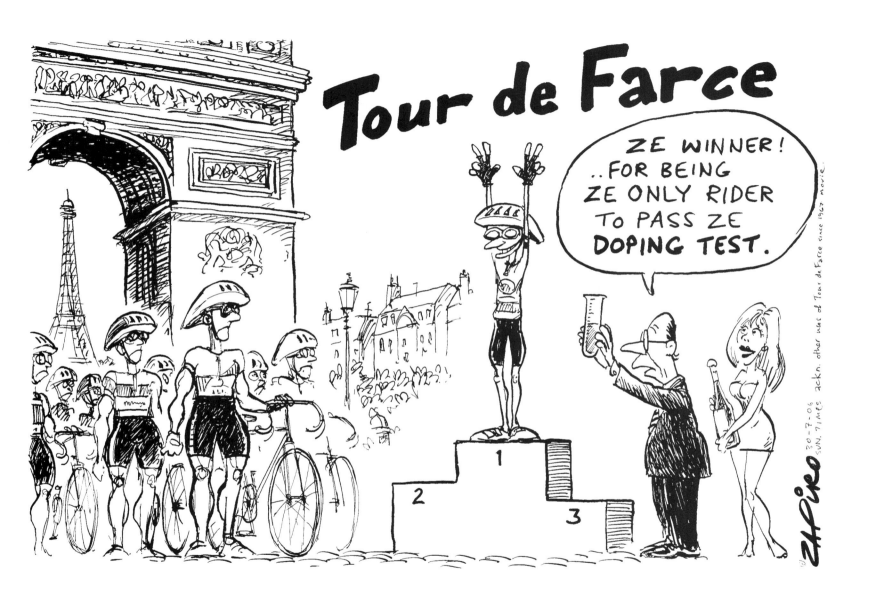

30 July 2006

Drug-soaked epic sees three of the favourites having to withdraw
at the start and the disqualification of winner Floyd Landis

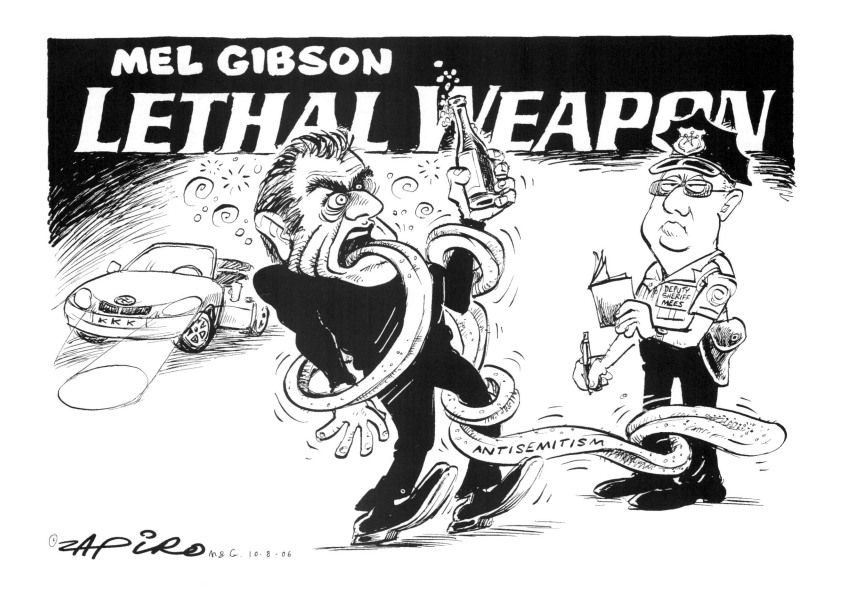

10 August 2006 Jewish arresting officer subjected to a rant about Jews causing every war

138

WELCOME ABOARD THIS **NO-HANDLUGGAGE LIQUID-ALERT** TRANSATLANTIC FLIGHT.

FASTEN YOUR HANDS NOW AND FOR YOUR OWN SAFETY KEEP THEM FASTENED WHERE WE CAN SEE THEM THROUGHOUT THE FLIGHT.

IMPORTANT SAFETY PROCEDURES ARE NOW BEING DEMONSTRATED BY THE CABIN CREW.

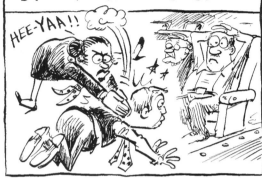

HEE-YAA!!

IN THE EVENT OF A **LIQUID EMERGENCY**, A **SNIFFER DOG** WILL DROP AUTOMATICALLY FROM THE SERVICE PANEL ABOVE YOU.

CABIN CREW WILL PROCEED SHORTLY WITH THE **PRE-BEVERAGE STRIP-SEARCH.**

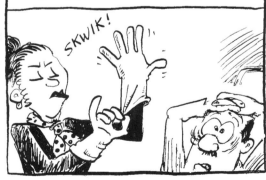

SKWIK!

NOW SIT TIGHT AND DON'T MAKE ANY SUDDEN MOVES. ..ENJOY THE FLIGHT.

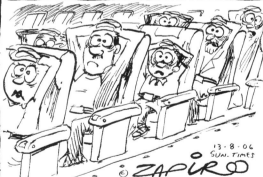

13-8-06 SUN.TIMES

ZAPIRO

13 August 2006 After terror plot foiled to blow up passenger planes using liquid explosives

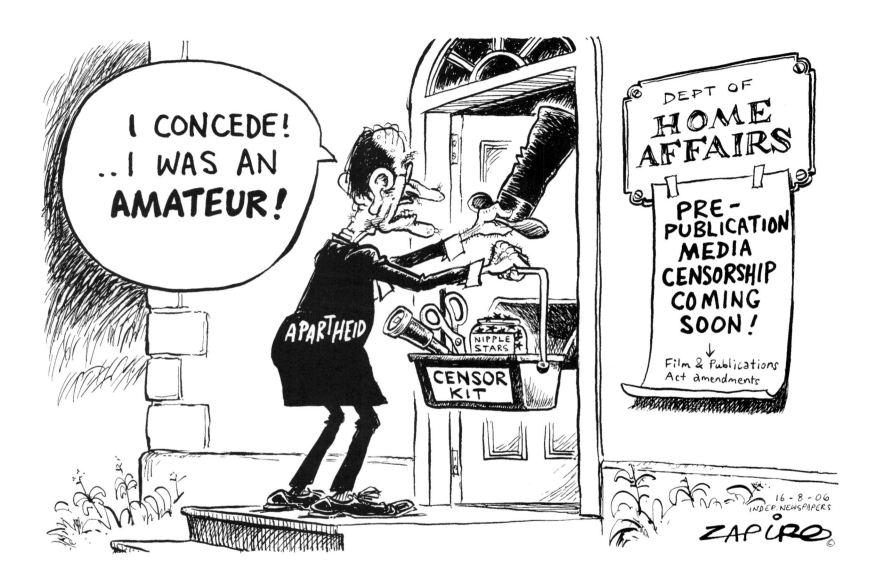

16 August 2006

Proposed law intended to curb child porn would have a draconian effect

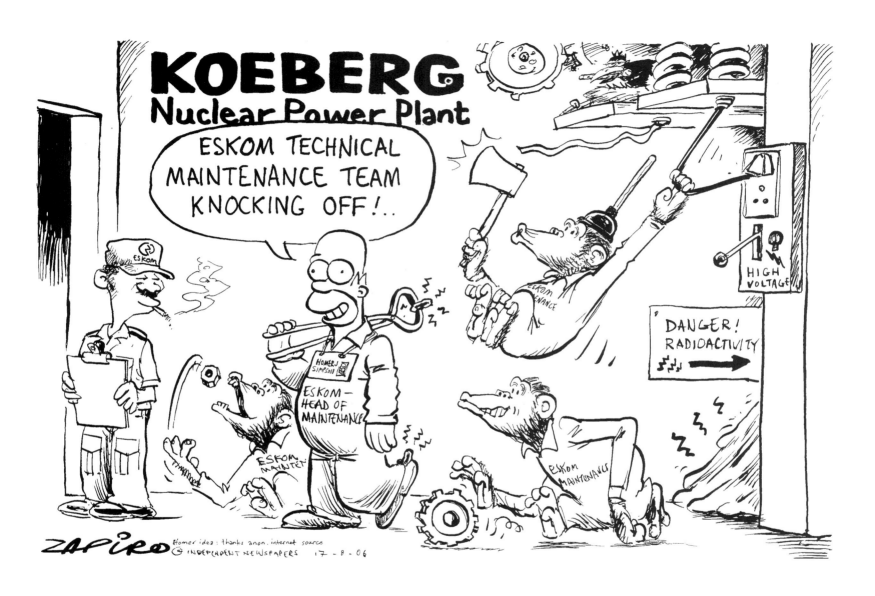

Leaked official report on the Cape power cuts points to negligence at Koeberg

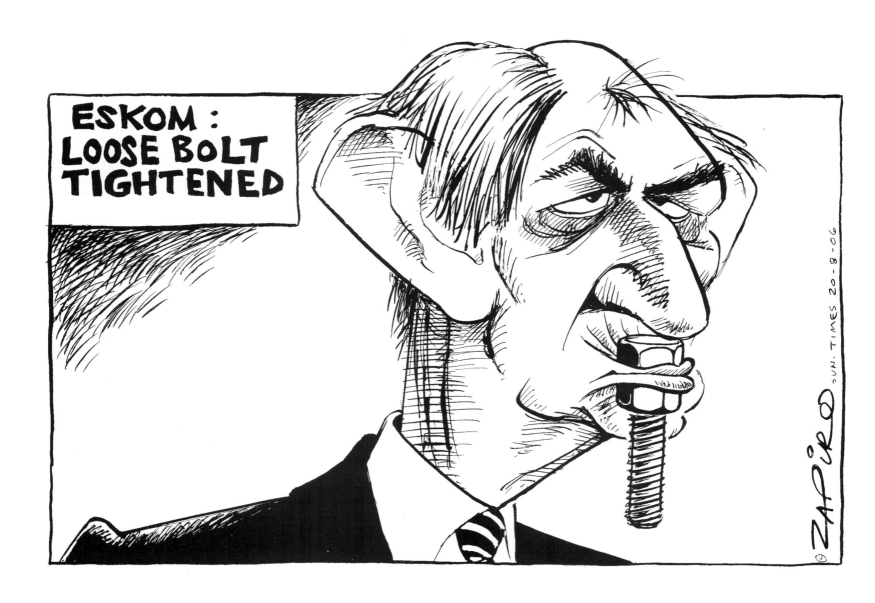

ESKOM :
LOOSE BOLT
TIGHTENED

20 August 2006

… which zaps Minister Alec Erwin's earlier claim
that the infamous bolt in the generator was sabotage

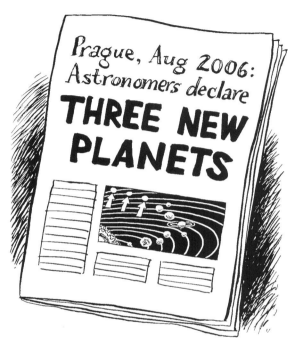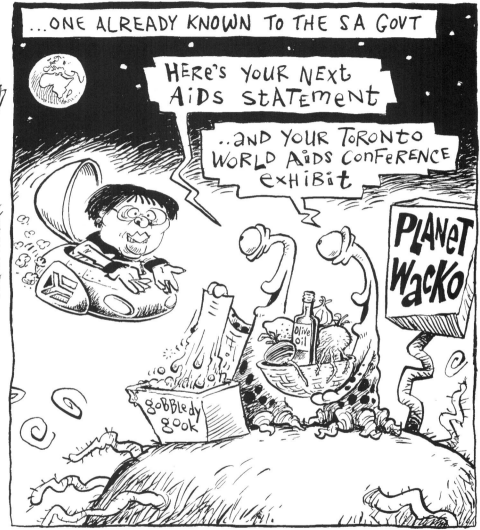

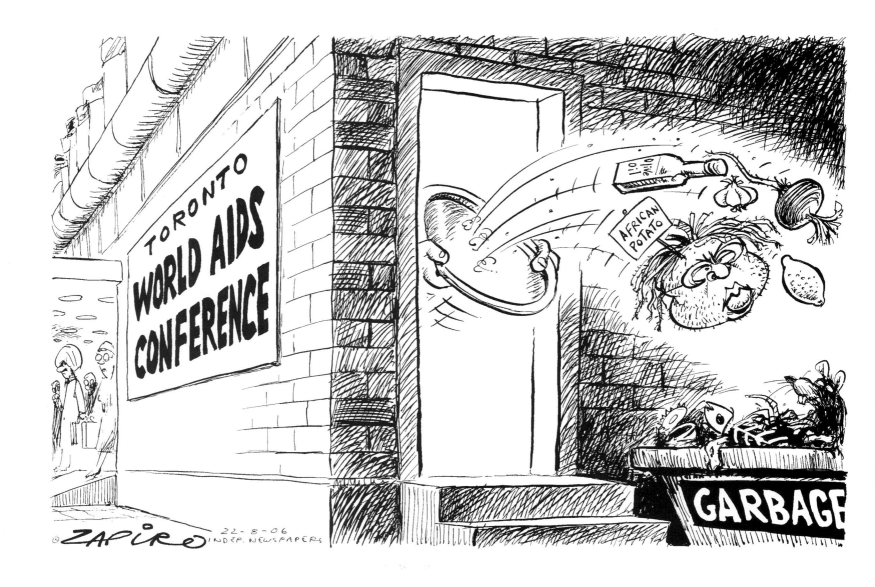

Experts and activists condemn SA government's 'lunatic fringe' Aids
theories and its exhibition display of vegetables in place of anti-retrovirals

22 August 2006

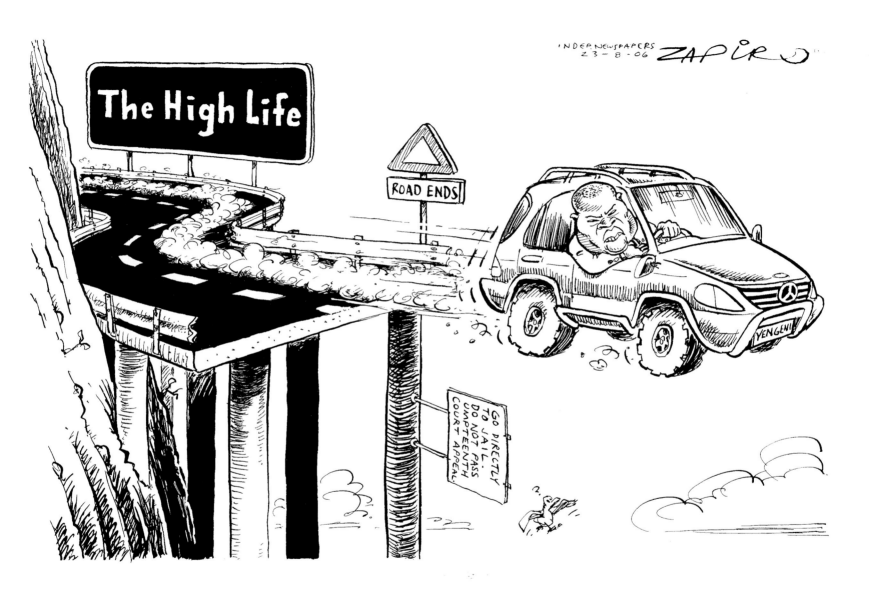

Former ANC chief whip Tony Yengeni, arrested 2001 for a large
4x4 kickback from an arms deal tender, sentenced 2003 to four years,
now has his conviction upheld. He (still defiantly) reports to prison.

23 August 2006

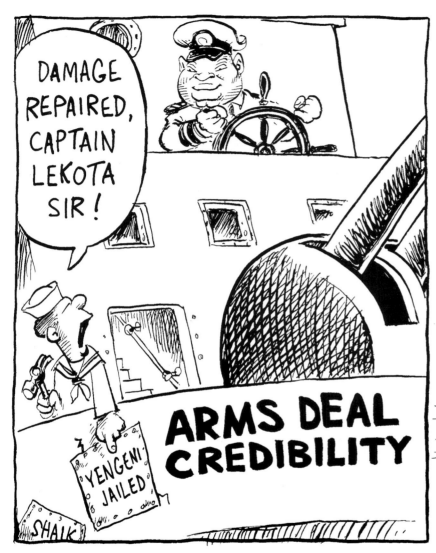
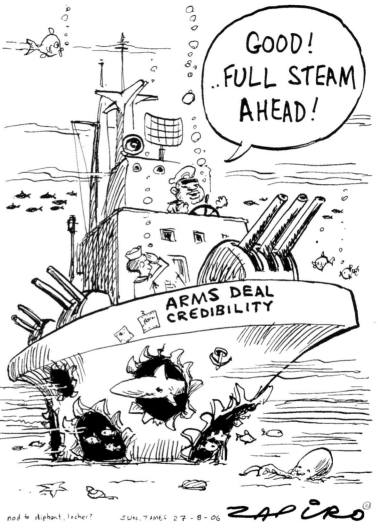

27 August 2006

GREAT MOMENTS IN BRAZILIAN FOOTBALL

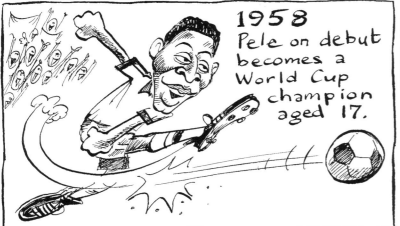

1958
Pele on debut becomes a World Cup champion aged 17.

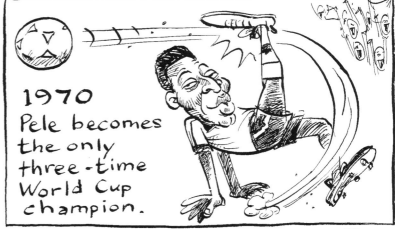

1970
Pele becomes the only three-time World Cup champion.

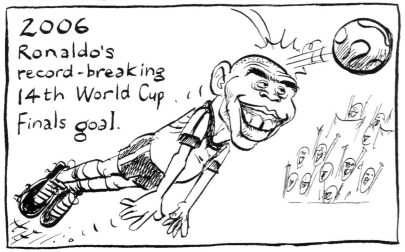

2006
Ronaldo's record-breaking 14th World Cup Finals goal.

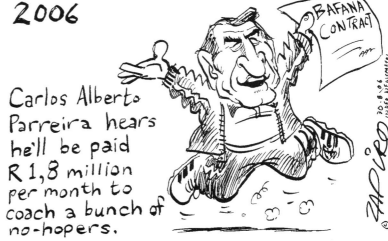

2006
Carlos Alberto Parreira hears he'll be paid R1,8 million per month to coach a bunch of no-hopers.

BAFANA CONTRACT

ZAPIRO 30.8.06 INDEP. NEWSPAPERS

30 August 2006

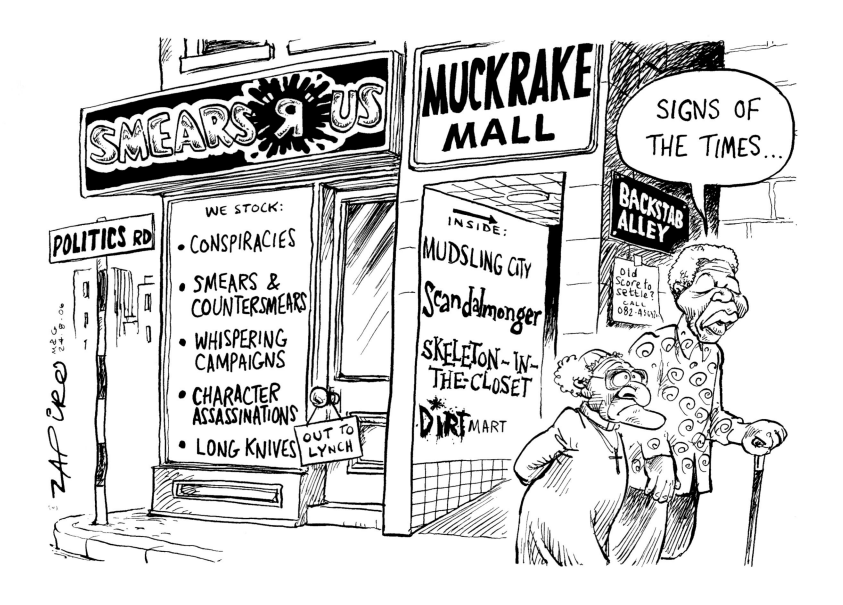

24 August 2006 The Tripartite Alliance riven by arms deal and Zuma saga factions

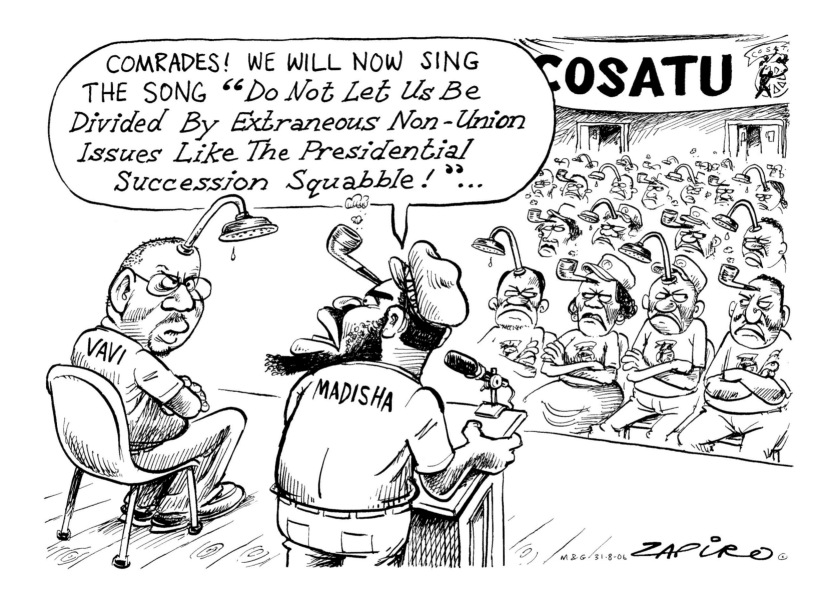

Animosity between Cosatu president Willie Madisha, seen as a
Mbeki man, and secretary-general Zwelinzima Vavi, a Zuma man

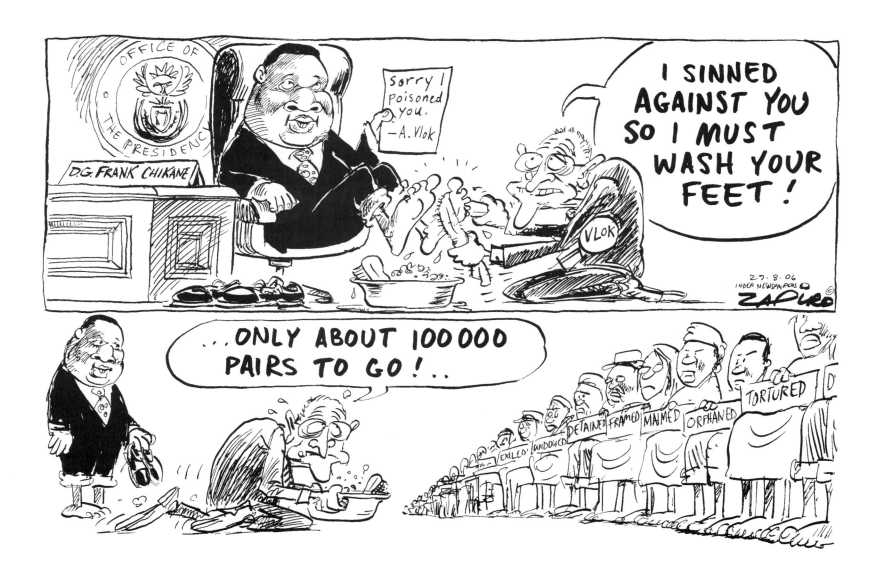

29 August 2006 Apartheid-era police minister Adriaan Vlok's biblical act of penance

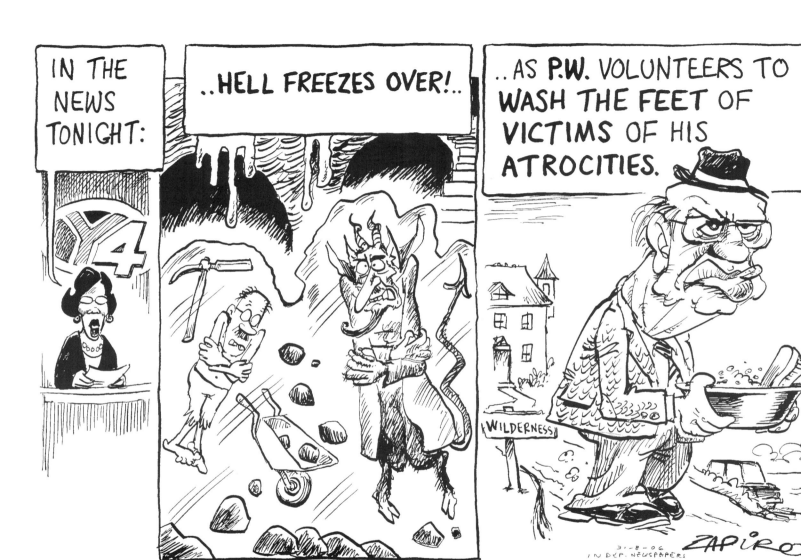

31 August 2006

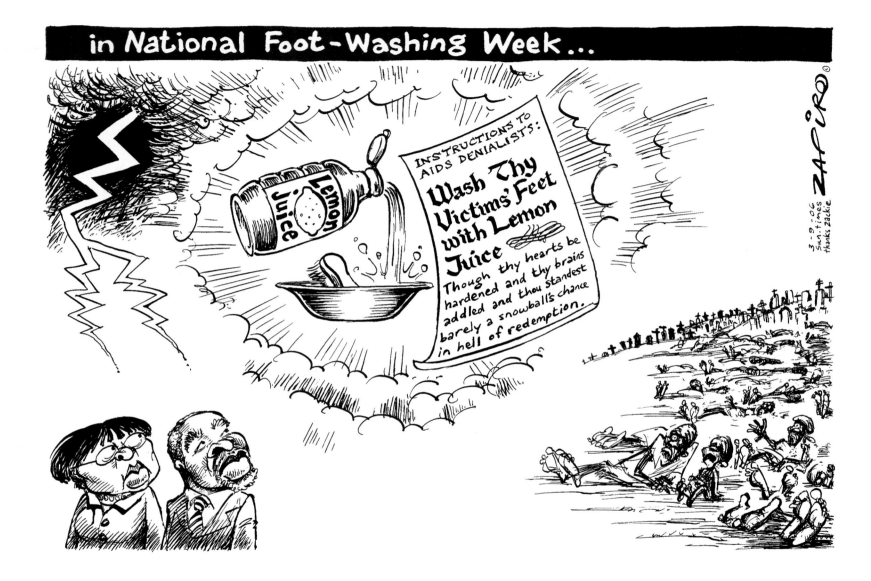

3 September 2006

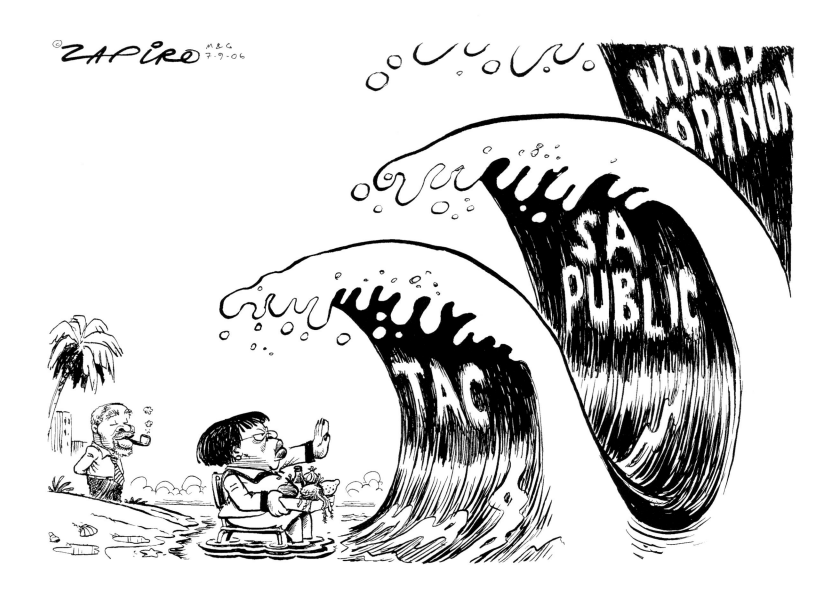

7 September 2006

Eighty international luminaries echo the
Treatment Action Campaign's call to axe the Health Minister

153

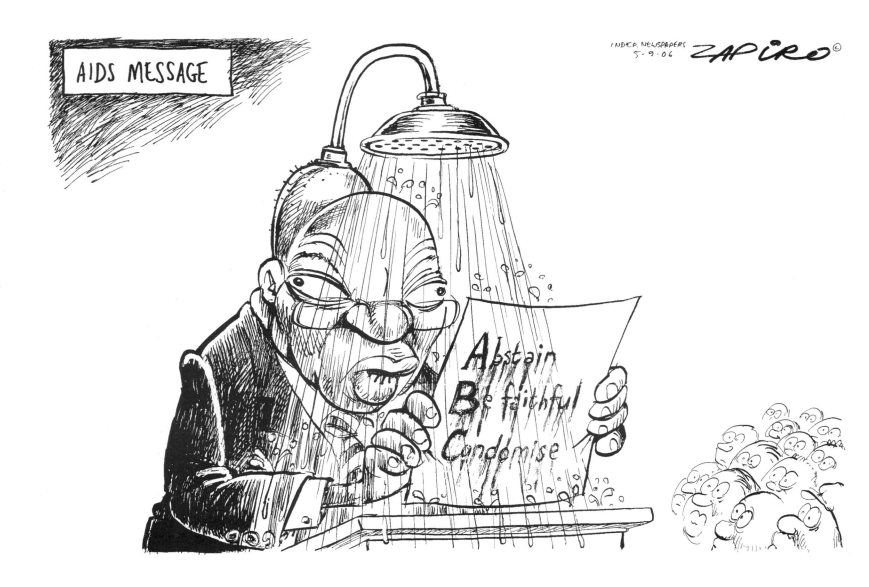

5 September 2006 Pronouncing authoritatively: 'we cannot afford any mixed messages or ambiguity ...'

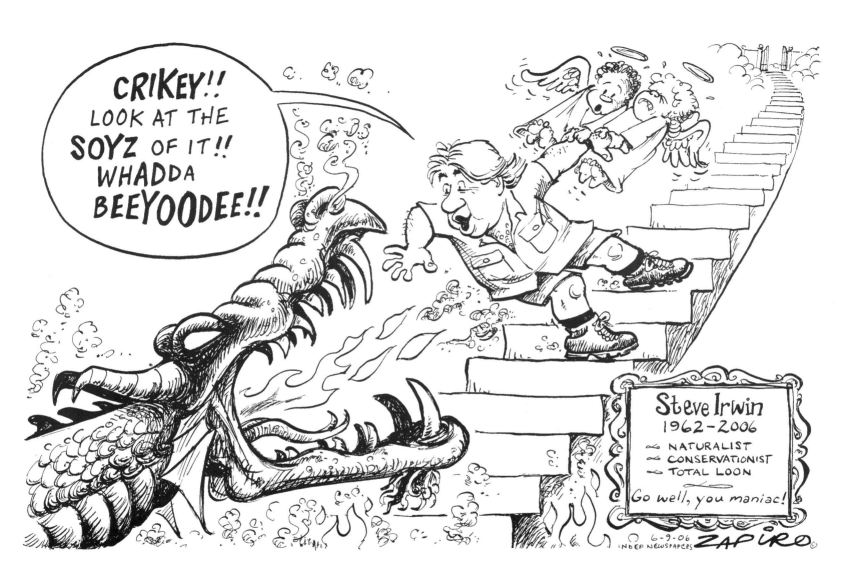

6 September 2006

10 September 2006

Partnering the US in the Iraq debacle has cost him
his popularity. He says he'll quit within a year.

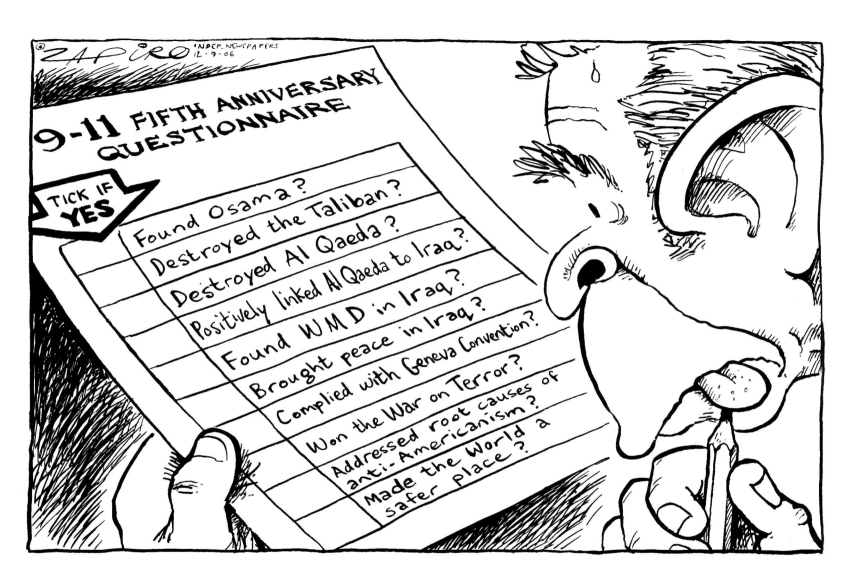

12 September 2006

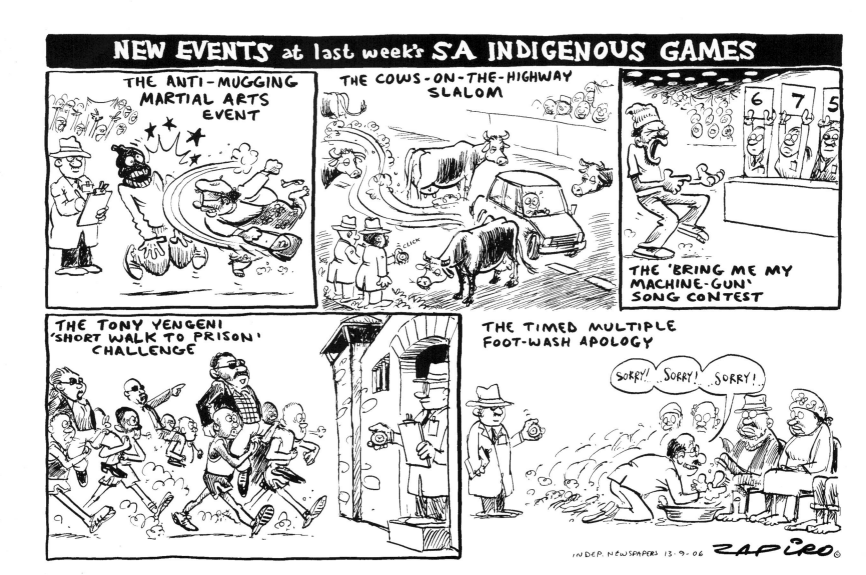

13 September 2006

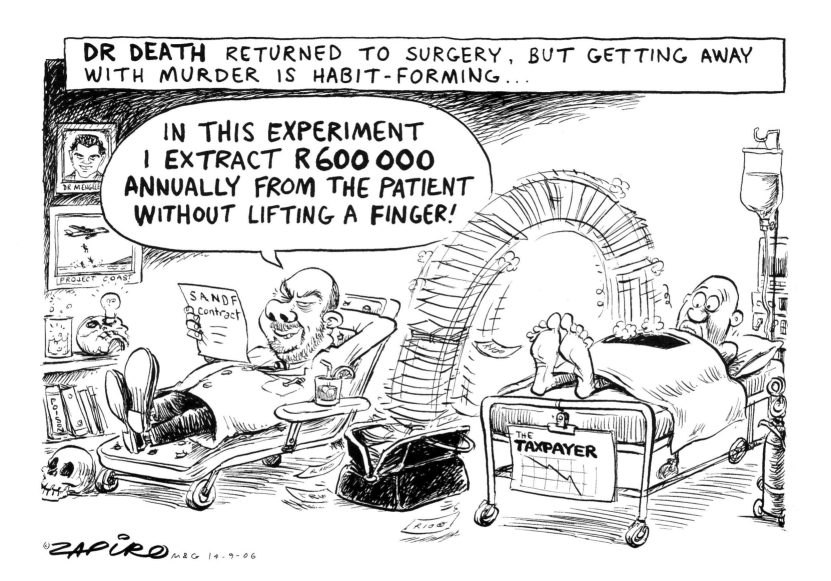

14 September 2006 His court case was finalised two years ago but he's still on well-paid suspension

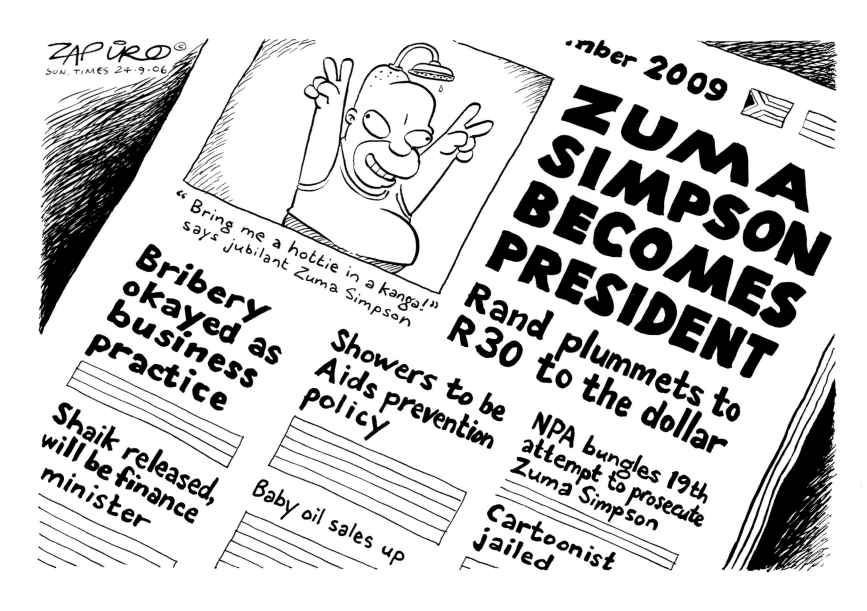

24 September 2006

Corruption charges against Zuma thrown out of court.
He may or may not be recharged. See next exciting episode.